INNOCENT LANDSCAPES

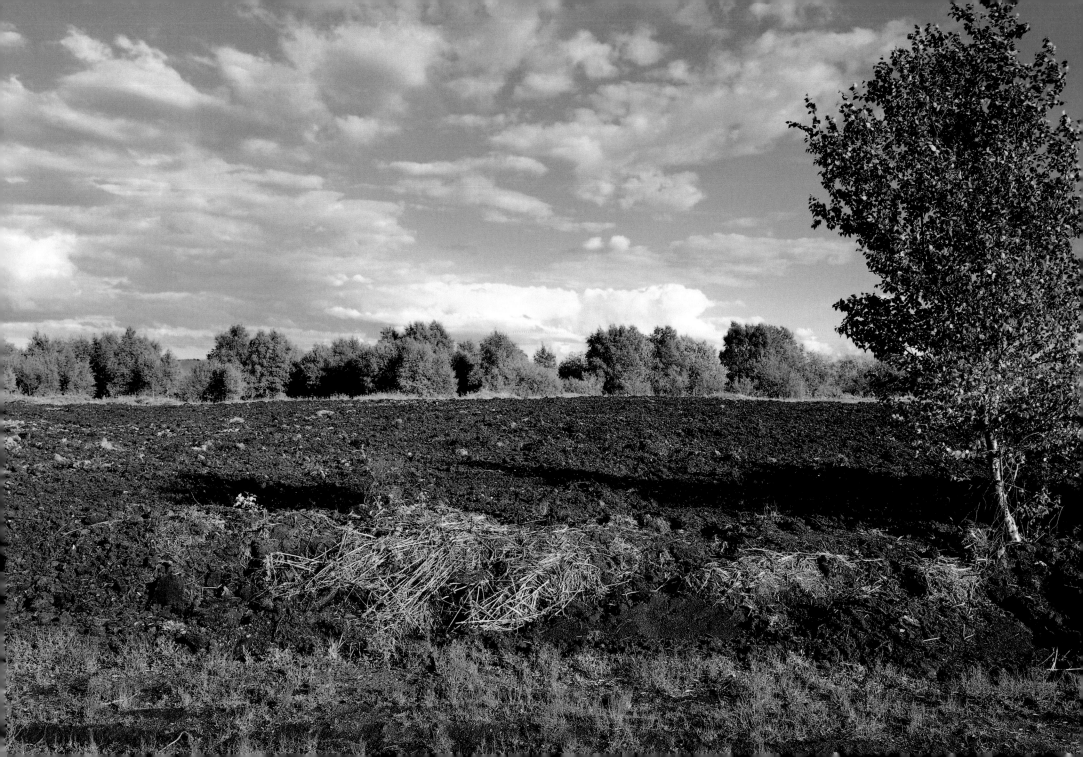

DAVID FARRELL

INNOCENT LANDSCAPES

DEWI LEWIS PUBLISHING

to my beloved Gudók
my inner eyes and second brain,
grazie

D

"I know your sorrow and I know that for the likes of us there is no ease for the heart to be had from words or reason and that in the very assurance of sorrow's fading there is more sorrow. So I offer you only my deeply affectionate and compassionate thoughts and wish for you only that the strange thing may never fail you, whatever it is, that gives us the strength to live on and on with our wounds."

Samuel Beckett

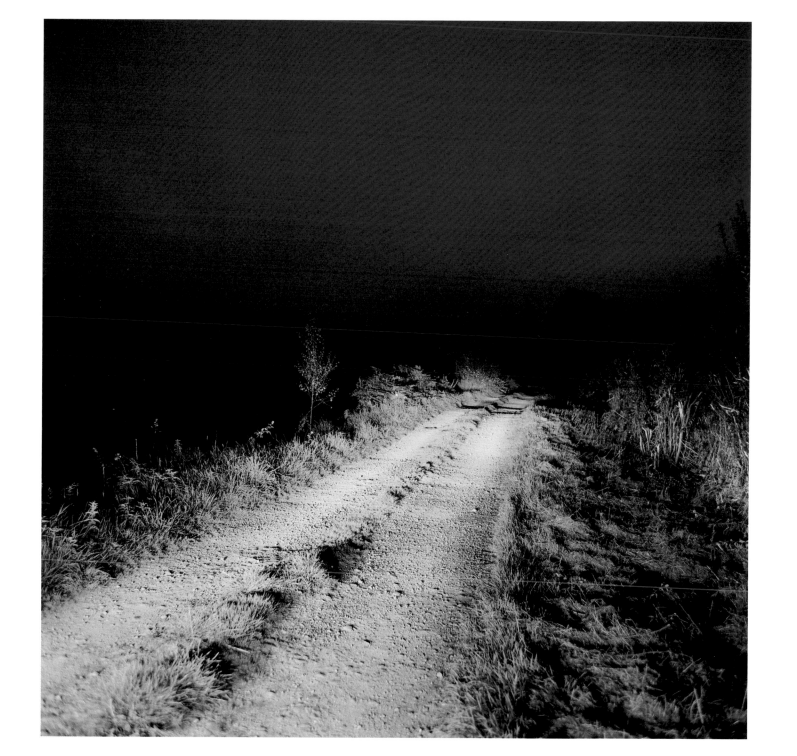

INTRODUCTION

It was a beautiful evening in late July 1999 when I left Annaghmaker-rig to drive to Colgagh with a local guide. We were heading for my first 'site' – where some three weeks earlier the remains of Brian McKinney and John McClory had been found.

For the last few miles of the journey the road weaved in and out of the North and the South. As we got closer my guide became a little confused, as if his recent memory of this now significant landscape was somehow being tested. We made wrong turns and drove past several times before eventually finding the small lane that would lead us to the site. It was an idyllic, rural, summer evening – birds singing, cattle in fields; a typically Irish (beautiful) 'innocent landscape', tranquil and calm.

The first thing I noticed was how the field seemed almost to have been violated; rough tyre tracks; groups of rocks piled here and there; a solitary silver birch tree abandoned on its side, its roots holding onto that circle of earth which had once held it firmly in place.

We walked slowly towards 'the spot', now marked by a large stone and a crude wooden cross. The contradictory feelings of presence and loss were intense – overwhelming. We were silent for some time, before I began to make a few perfunctory photographs – my attempt to deal with the sensations and emotions I felt. But my camera was not its usual shield. Here was a paradox of beauty and savagery, tranquillity and sorrow. I would have to return, perhaps many times, to be able to deal with it.

On May 27th 1999 The Northern Ireland Location of Victims Remains Bill was passed in the House of Commons. It offered an amnesty for those providing information concerning the identification and location of what became known as the 'Sites of The Disappeared'. The six sites revealed were the burial places of eight people murdered by the IRA in the 1970s and early 1980s. Though they belonged to the savagery of a thirty year conflict, they somehow stood apart. They were the missing, they were Catholic and had not only been taken from their families but also from their 'homeland' to be buried in the South.

As I revisited these places that final twist disturbed my notions of landscapes; of Northern and troubled – Southern and peaceful. I also found myself grasping at the naïve hope that perhaps I might find something that had been overlooked or that the earth might have settled and would itself reveal something.

On May 20th, 2000 the digs, now in their second phase, were finally suspended: three remains had been located, three closures permitted. For the remaining six families there was a site rather than a spot, a closing rather than a closure.

David Farrell, May 2001

COLGAGH

BALLYNULTAGH

ORISTOWN

TEMPLETOWN

WILKINSTOWN

BRAGAN

FAUGHART

BRIAN MCKINNEY

JOHN MCCLORY

DANNY MCILHONE

BRENDAN MEGRAW

JEAN MCCONVILLE

KEVIN MCKEE

SEAMUS WRIGHT

COLUMBA MCVEIGH

EAMONN MOLLOY

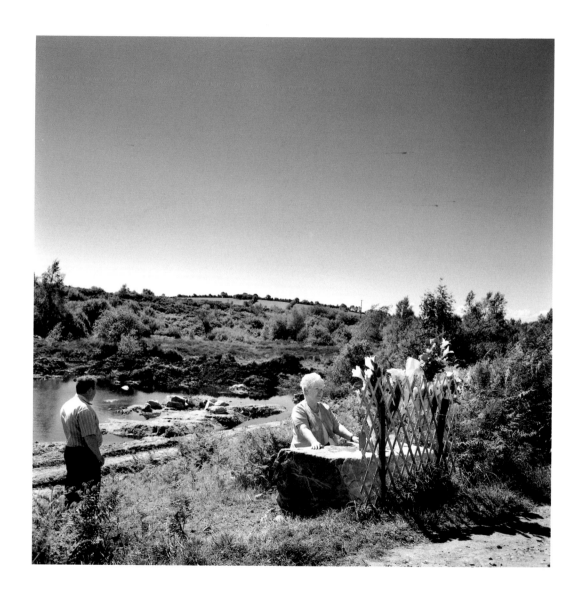

COLGAGH

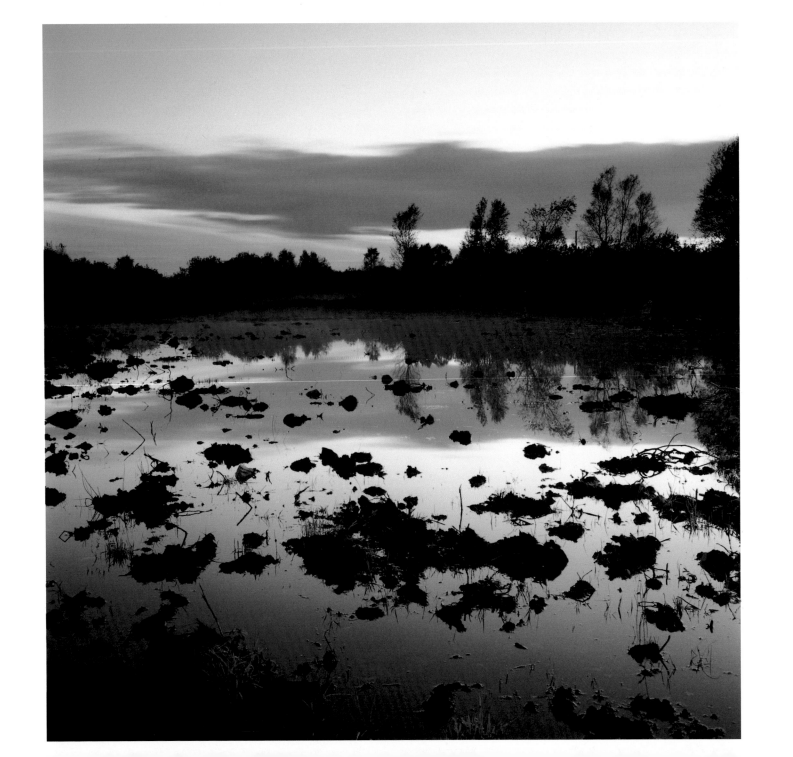

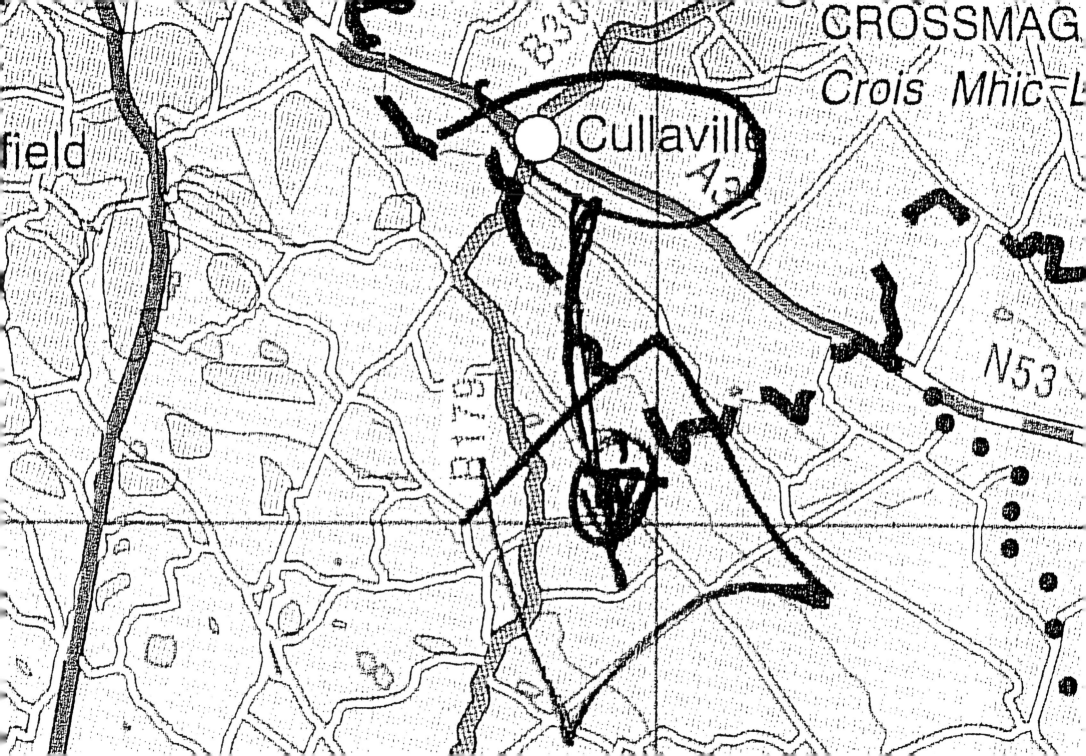

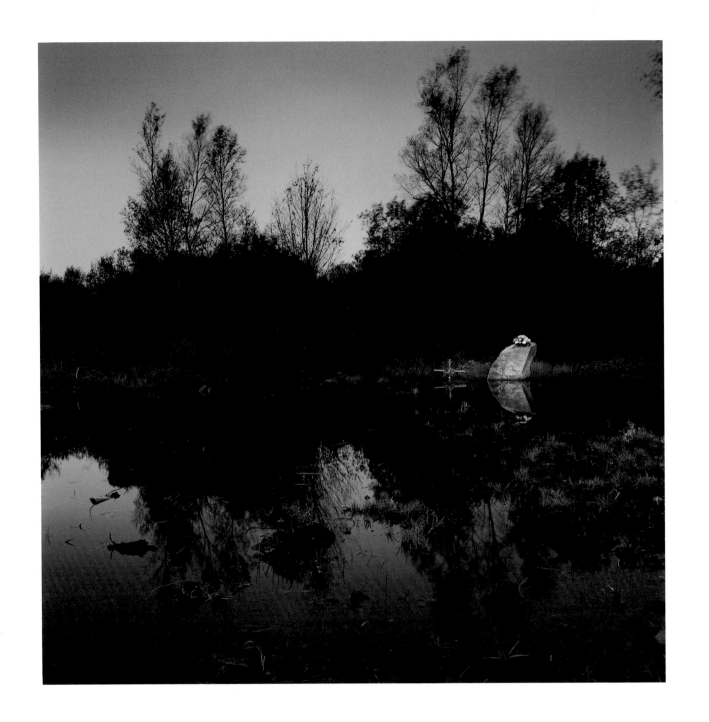

BRIAN McKINNEY

JOHN McCLORY

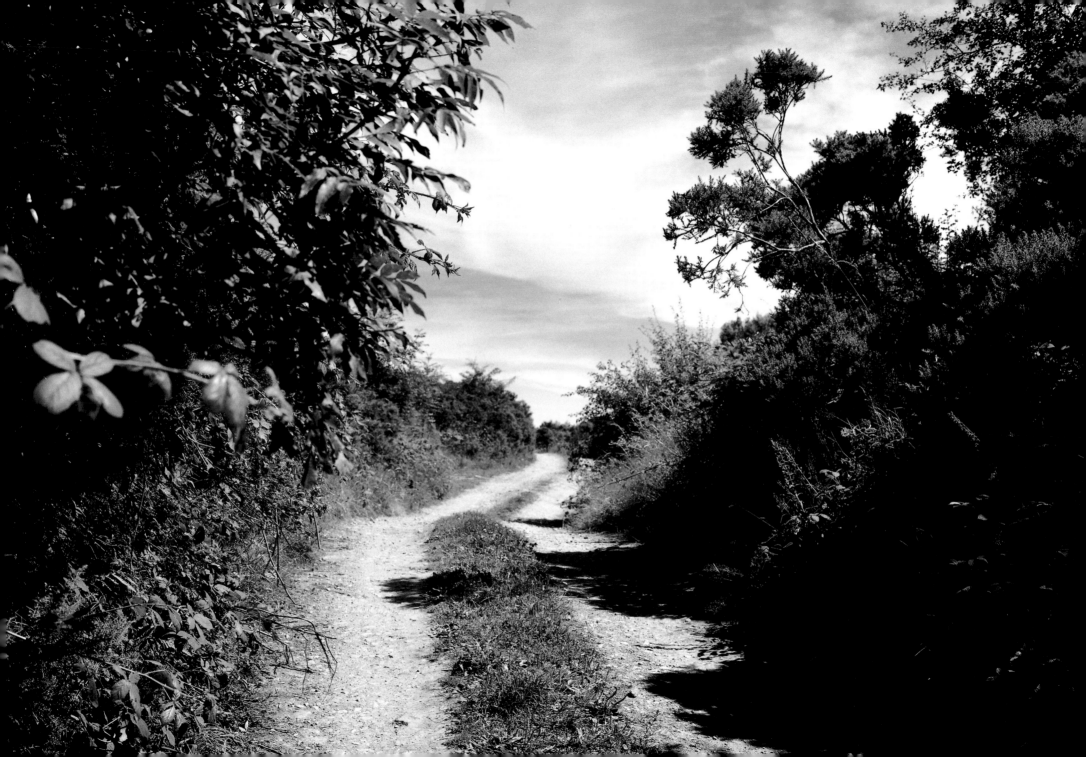

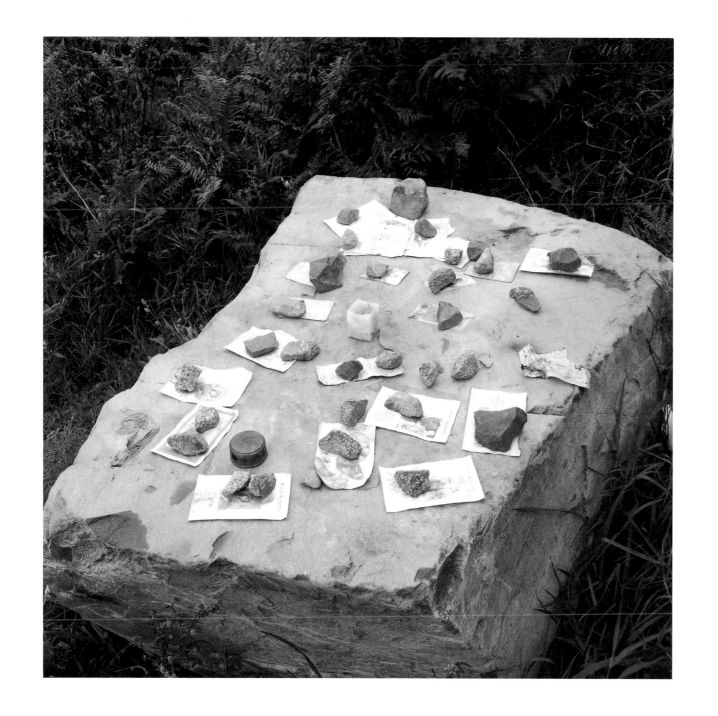

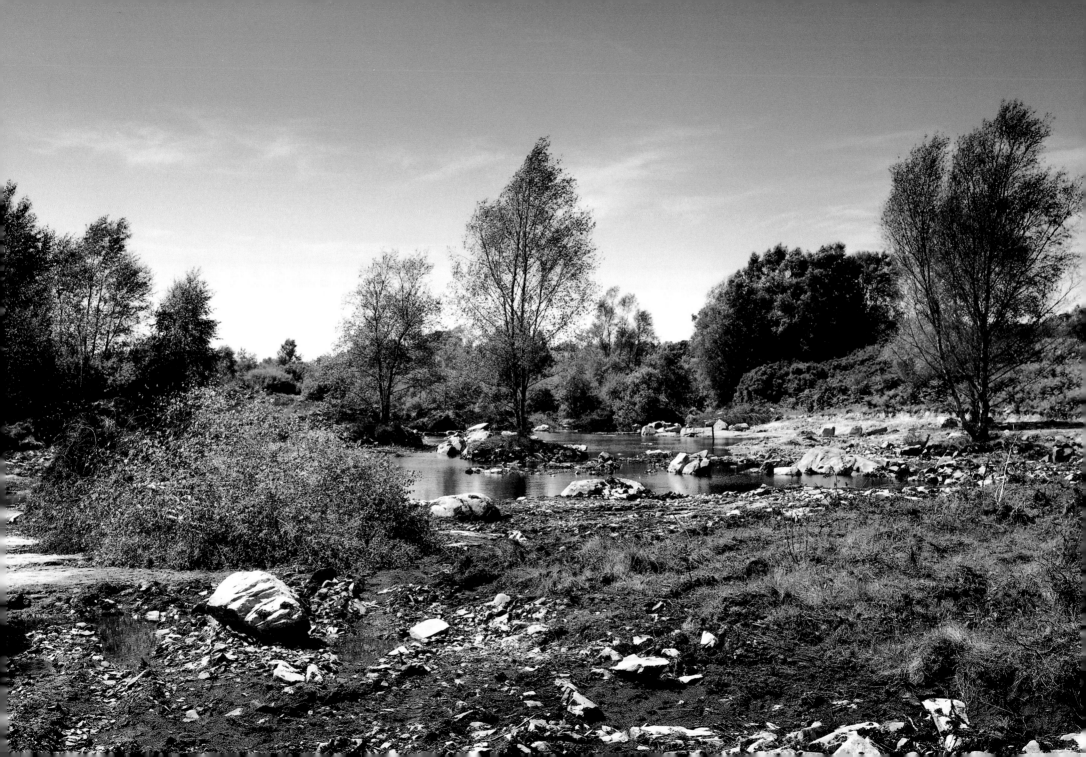

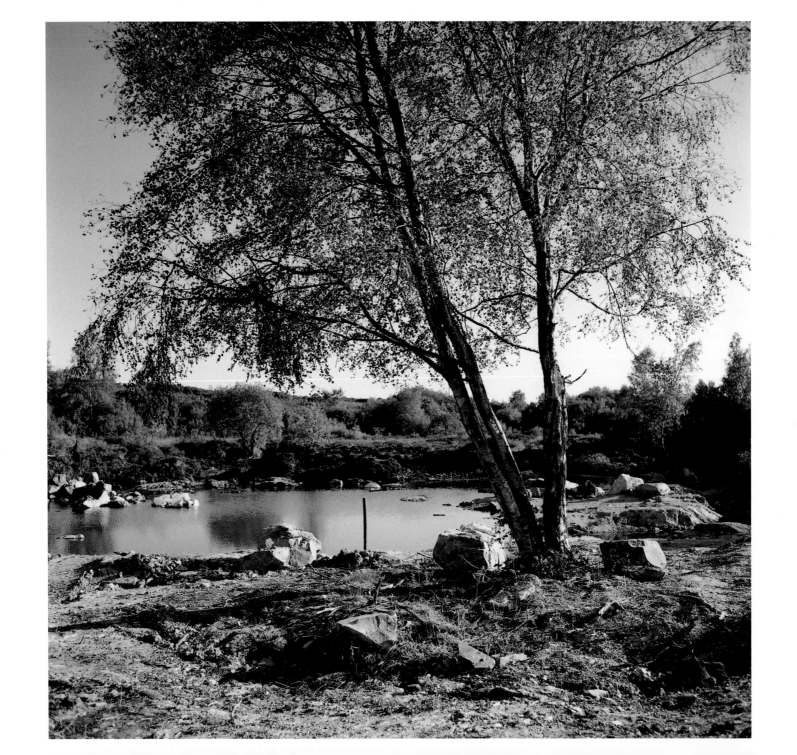

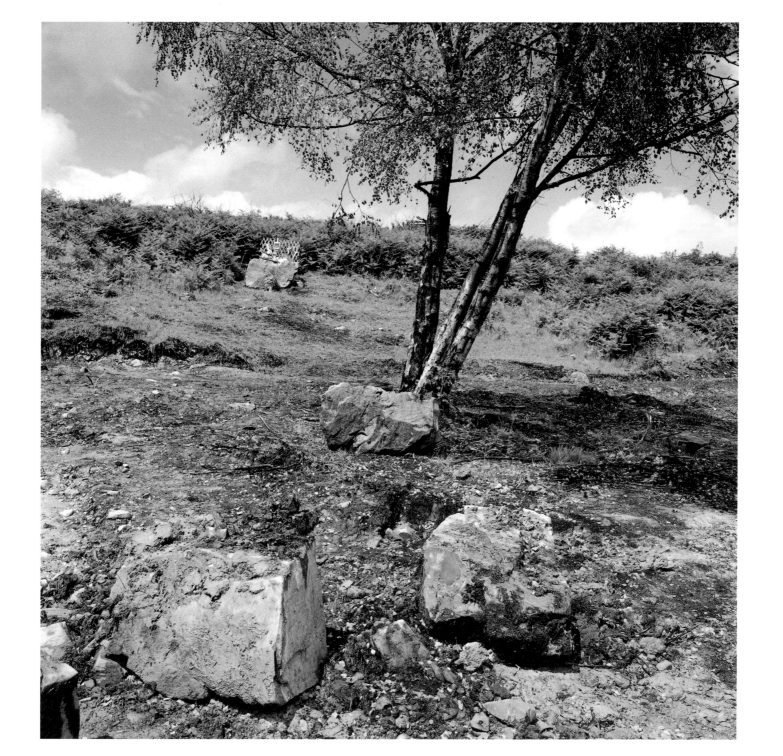

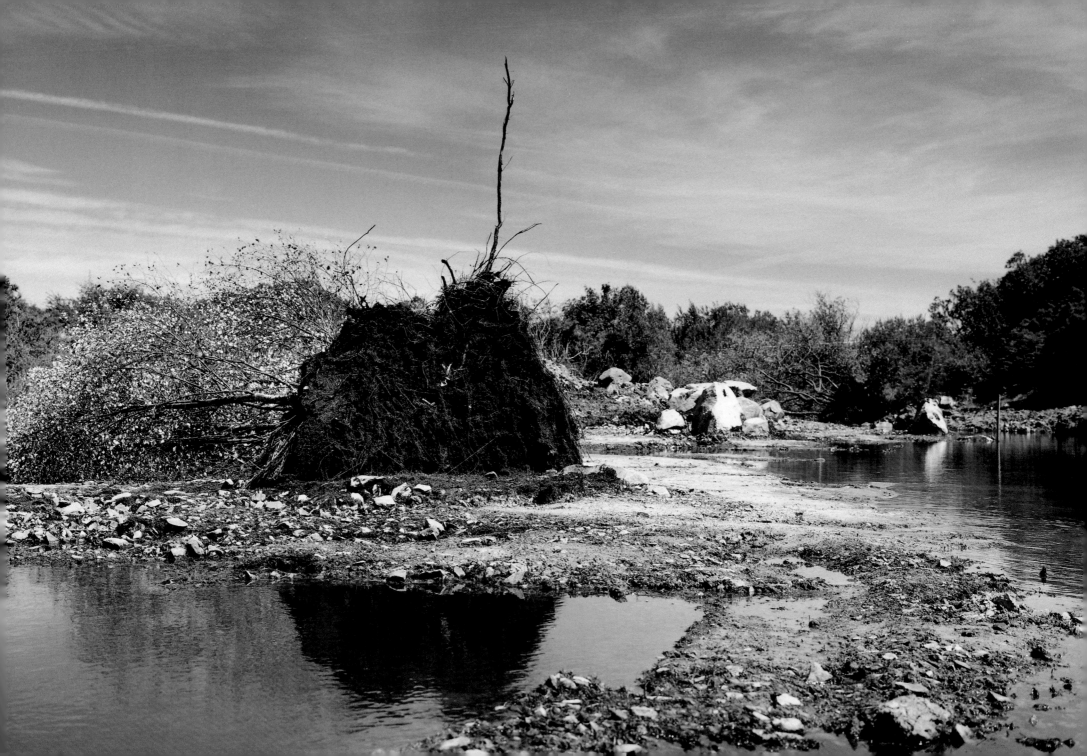

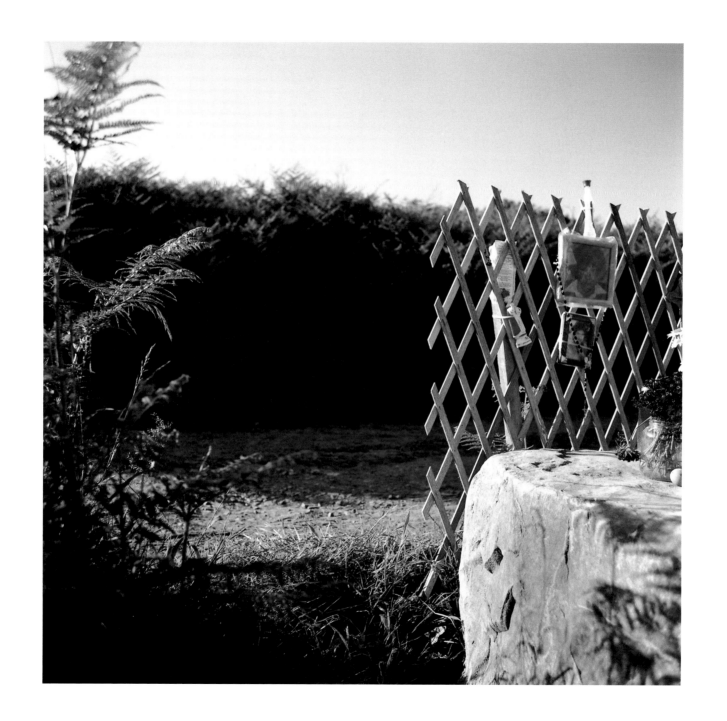

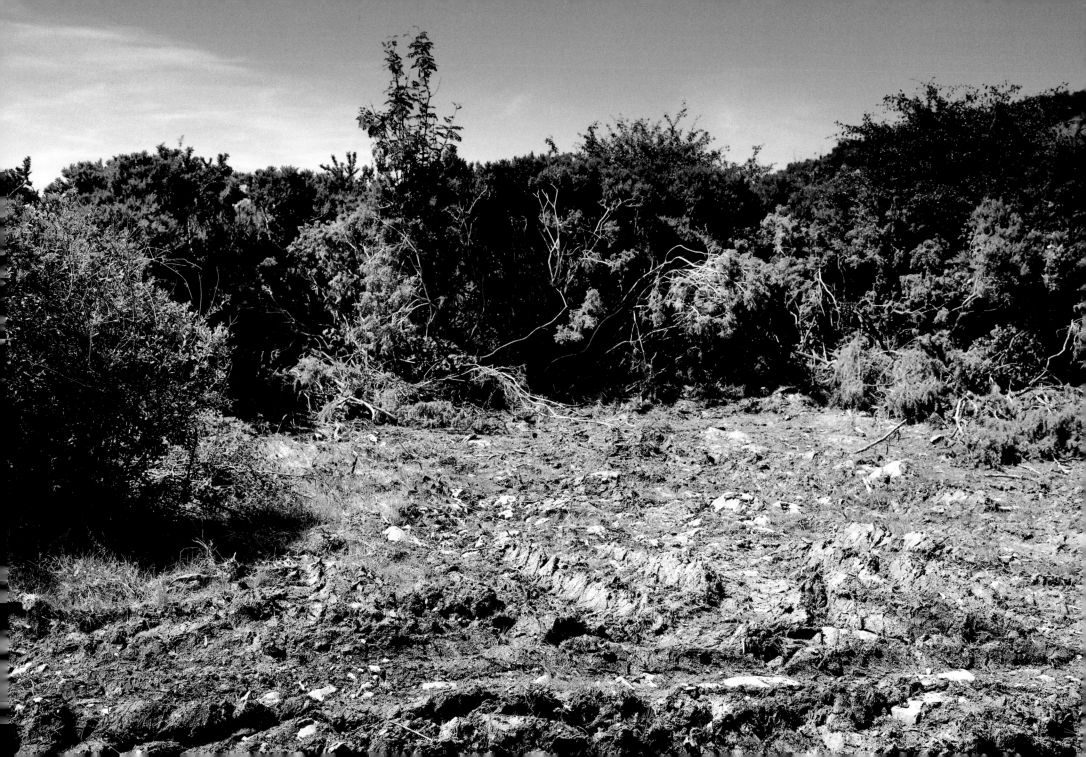

BALLYNULTAGH

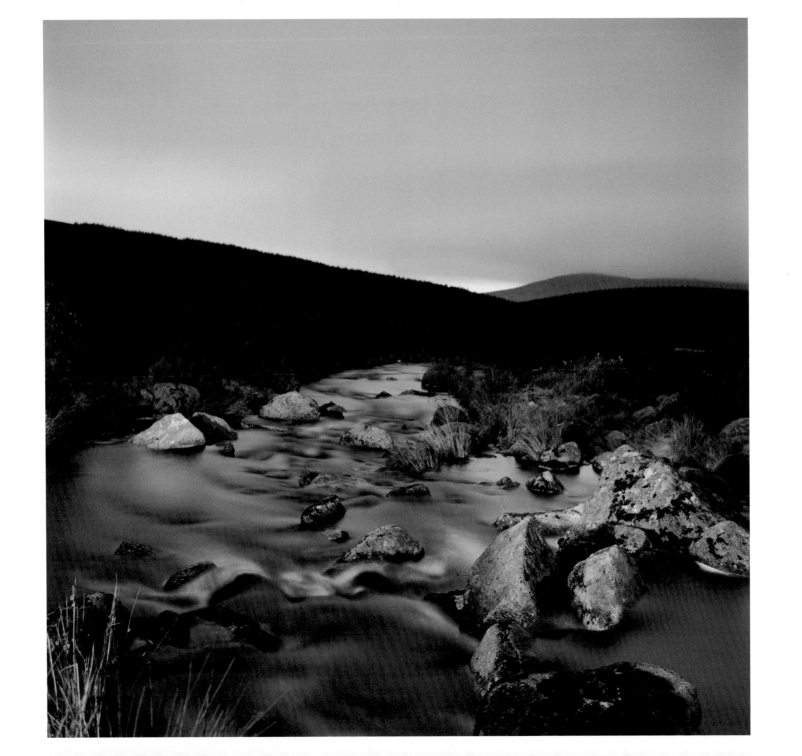

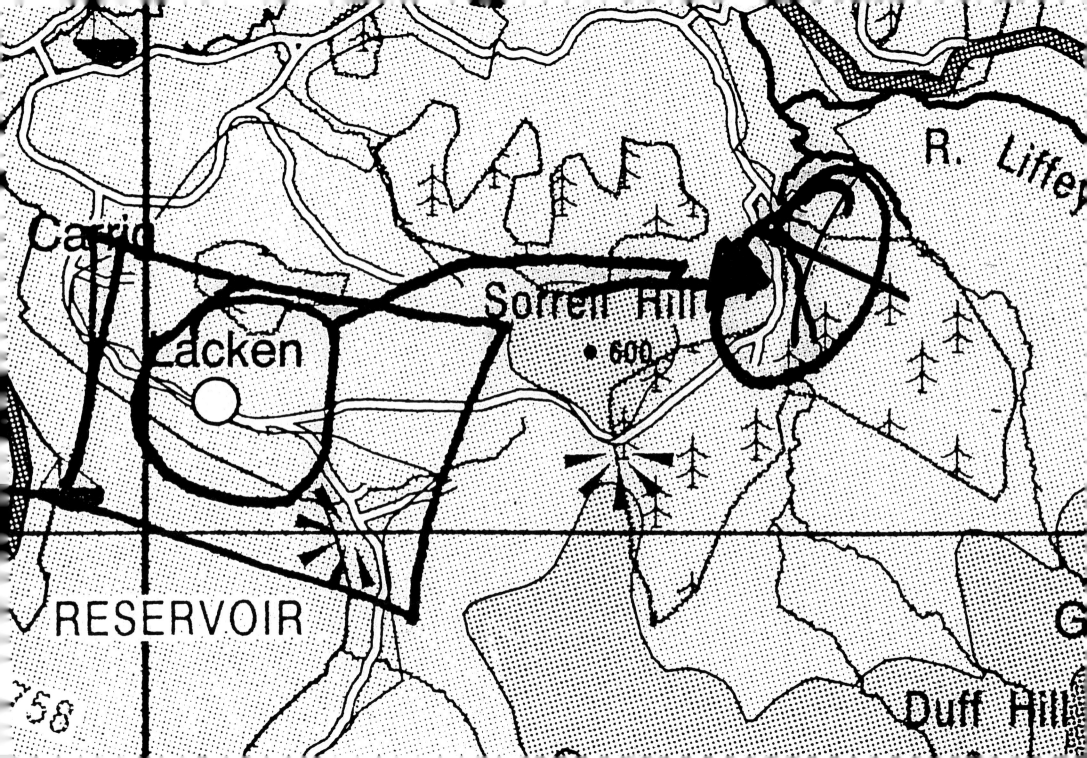

RESERVOIR

Carri

acken

Sorren Hill

• 600

R. Liffe

Duff Hill

58

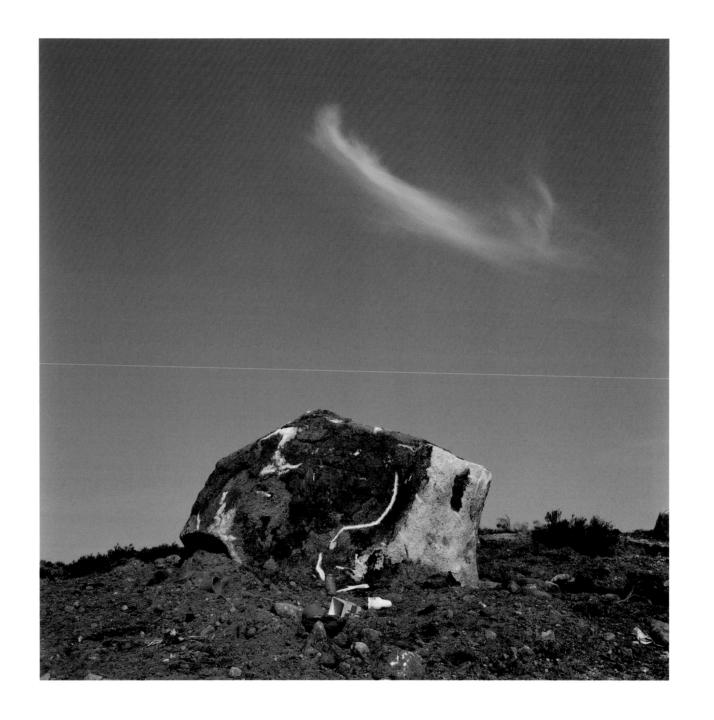

DANNY MCILHONE

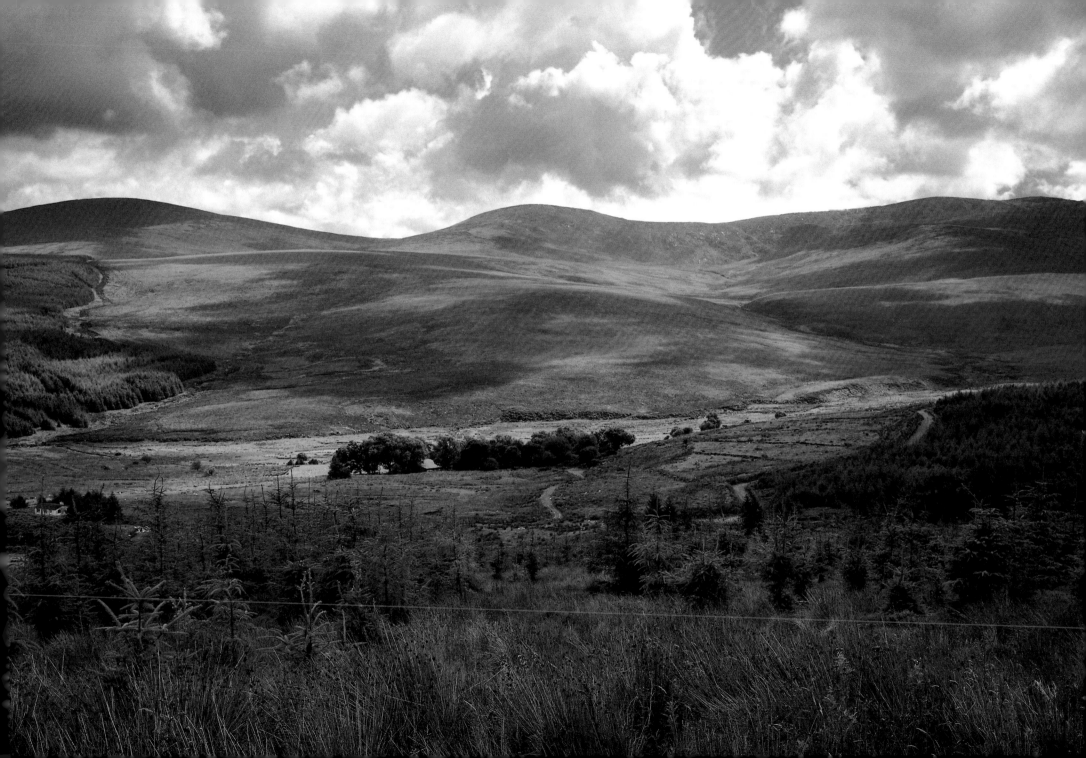

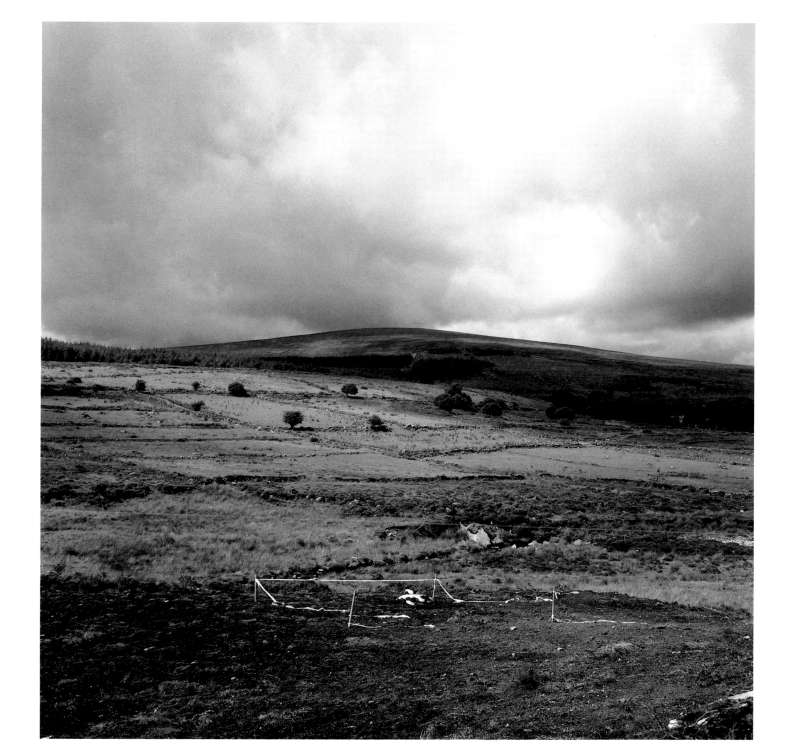

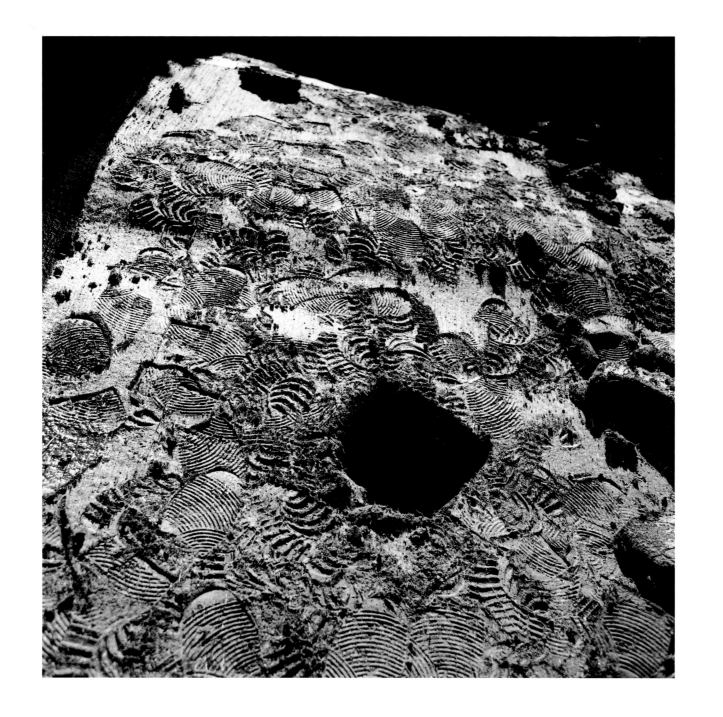

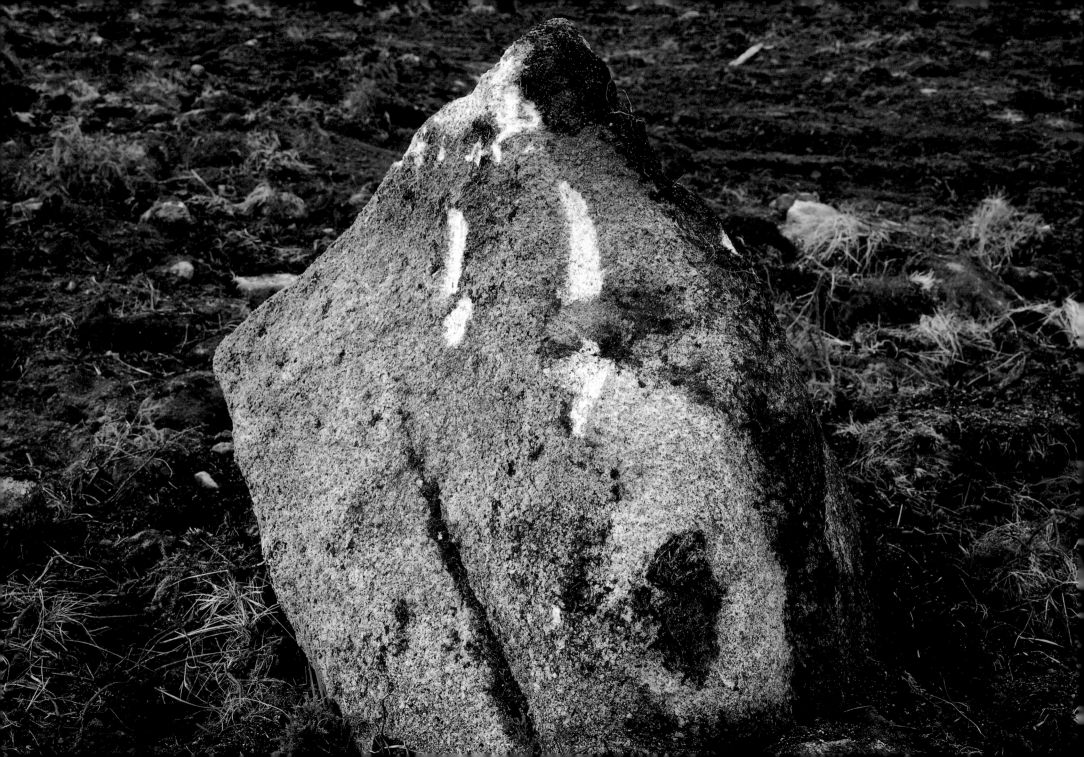

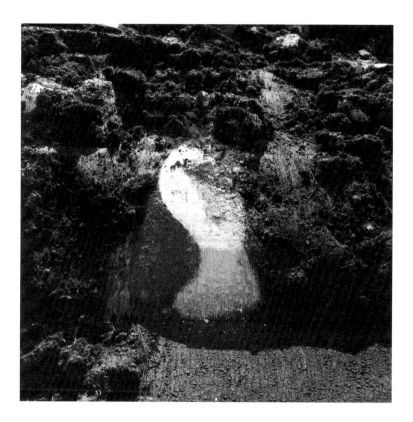 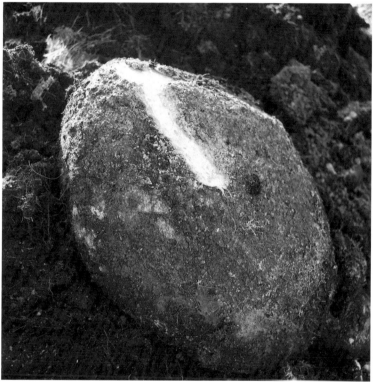

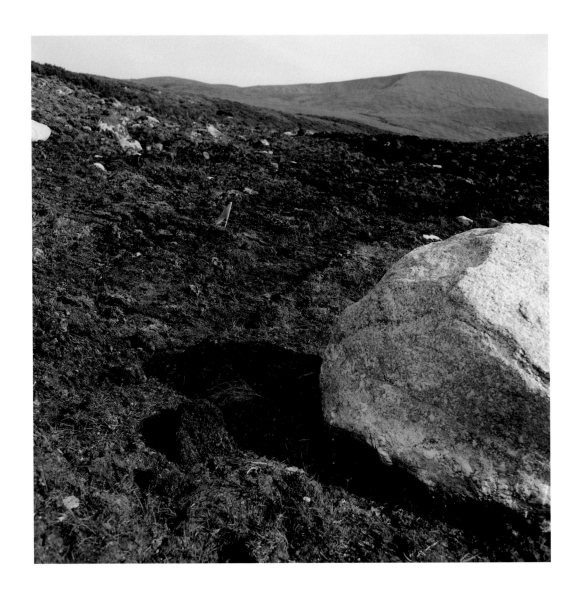

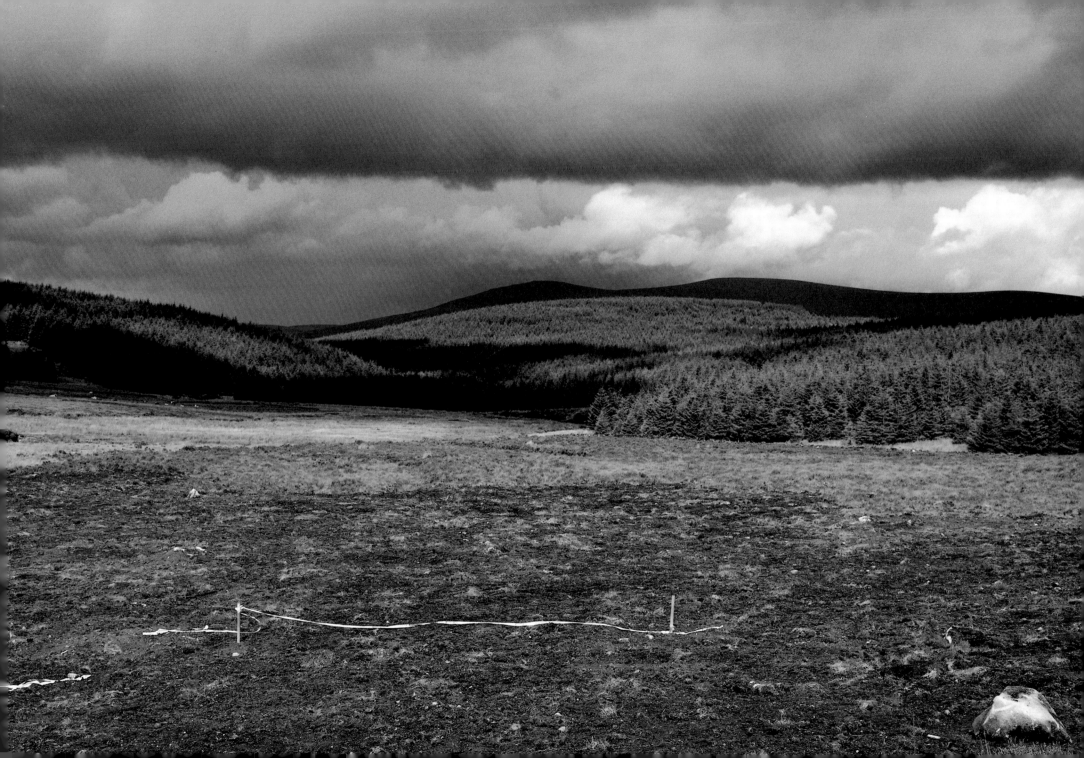

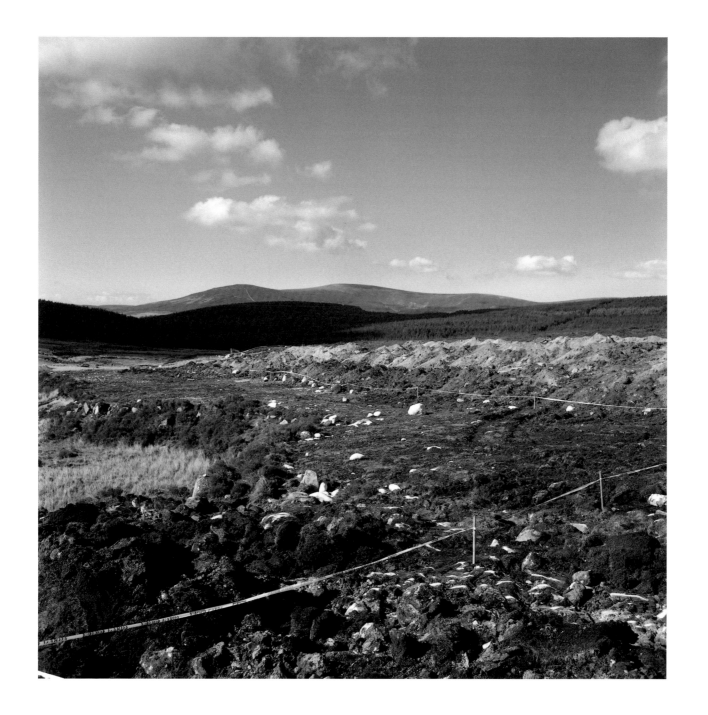

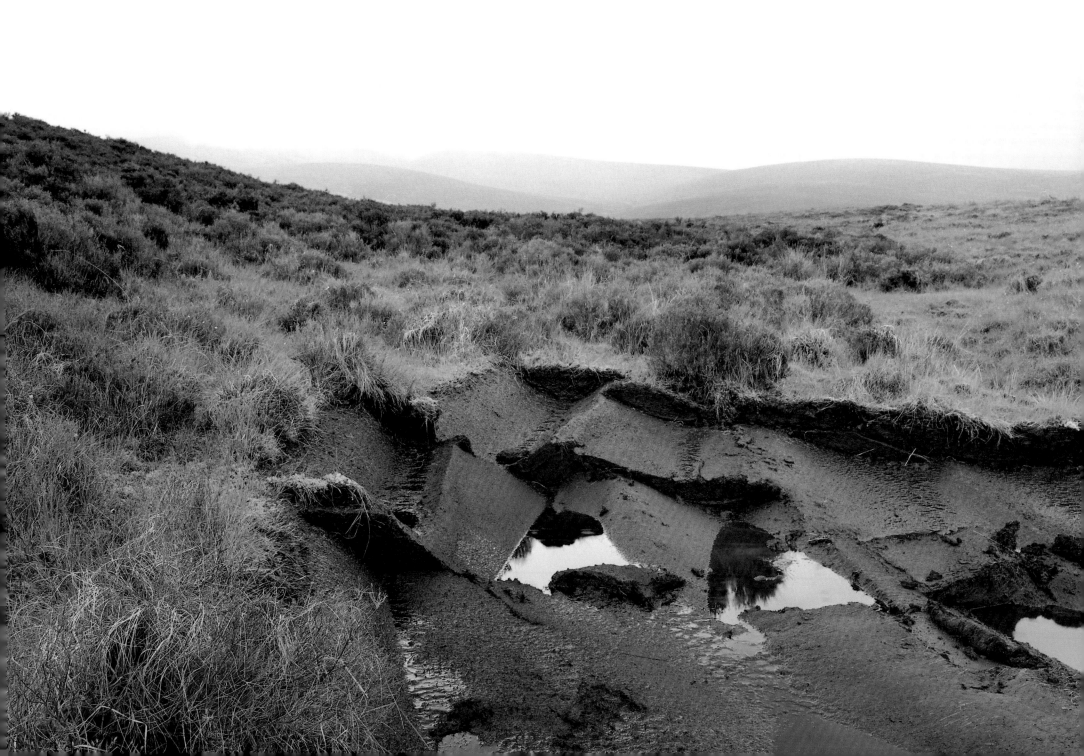

ORISTOWN

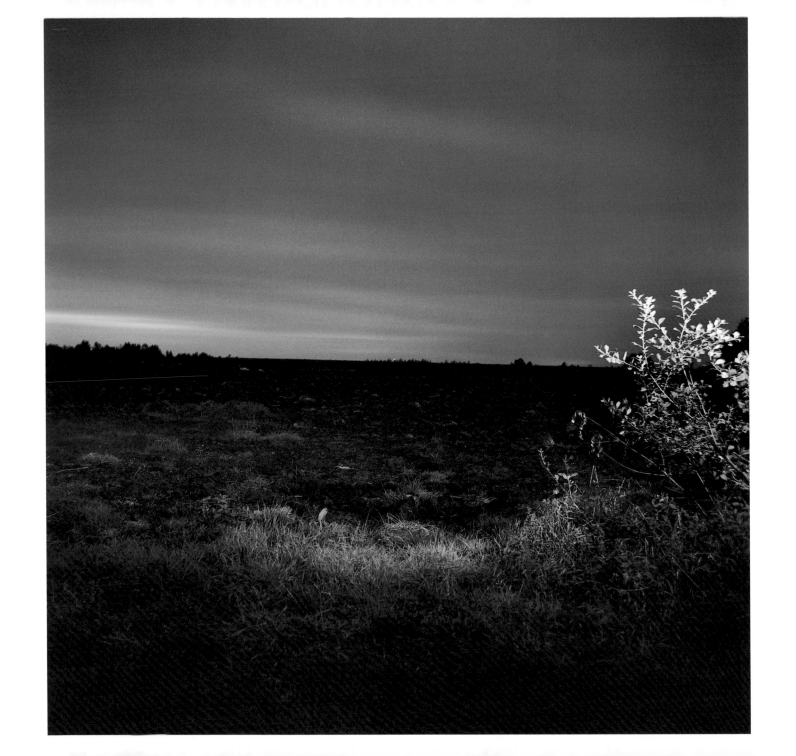

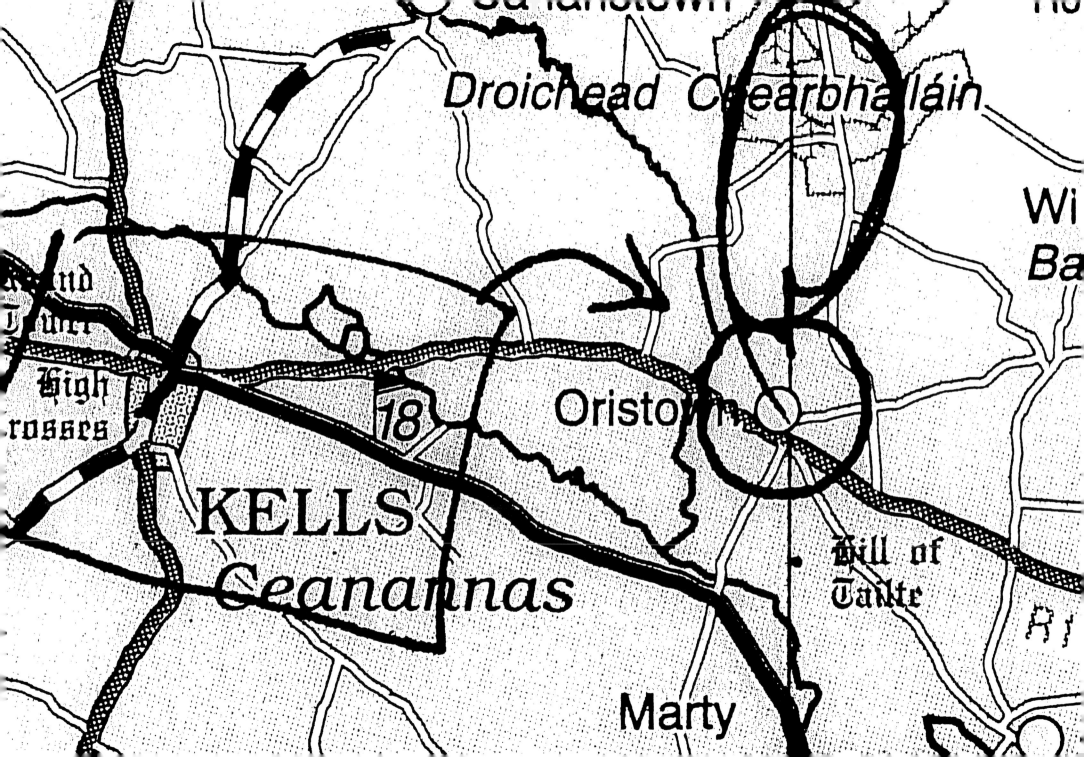

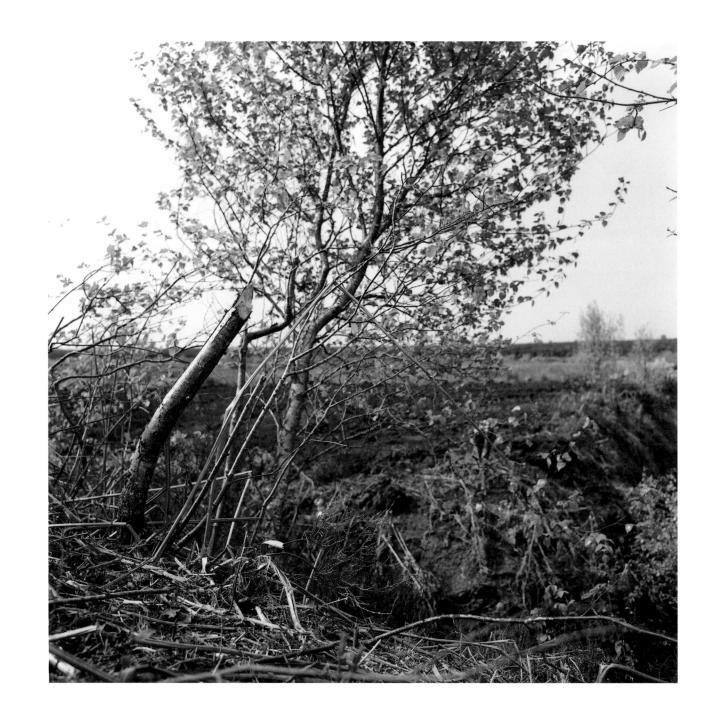

BRENDAN MEGRAW

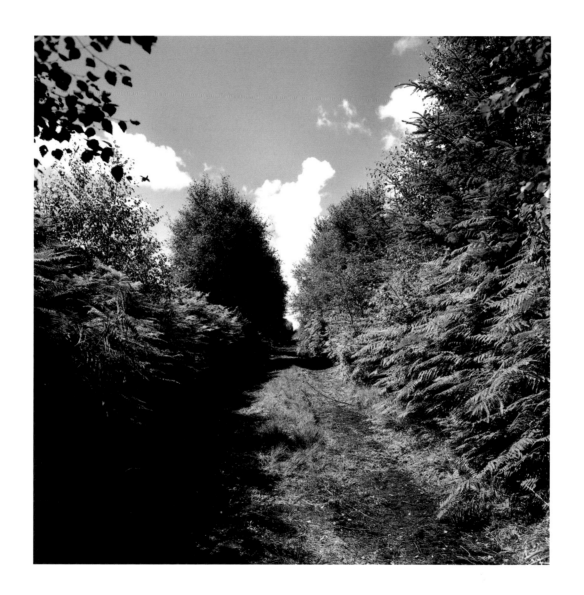

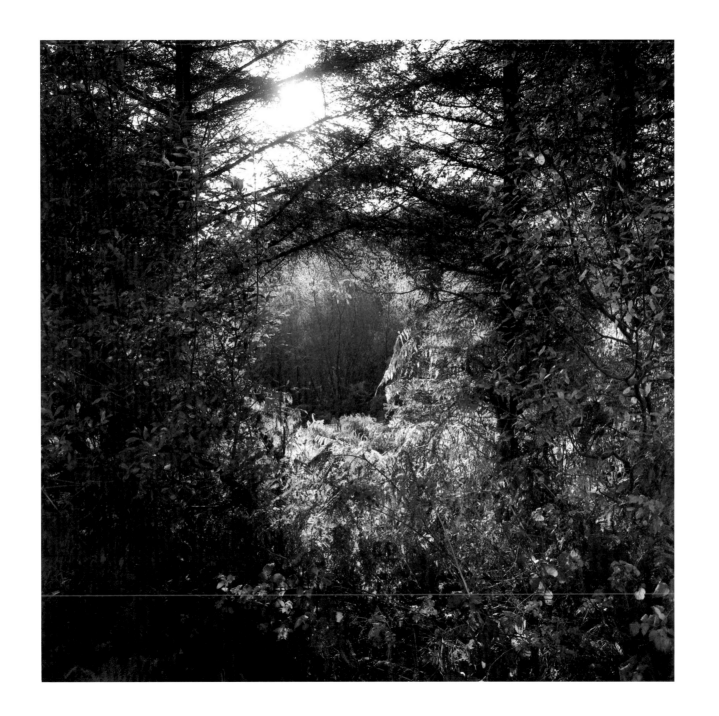

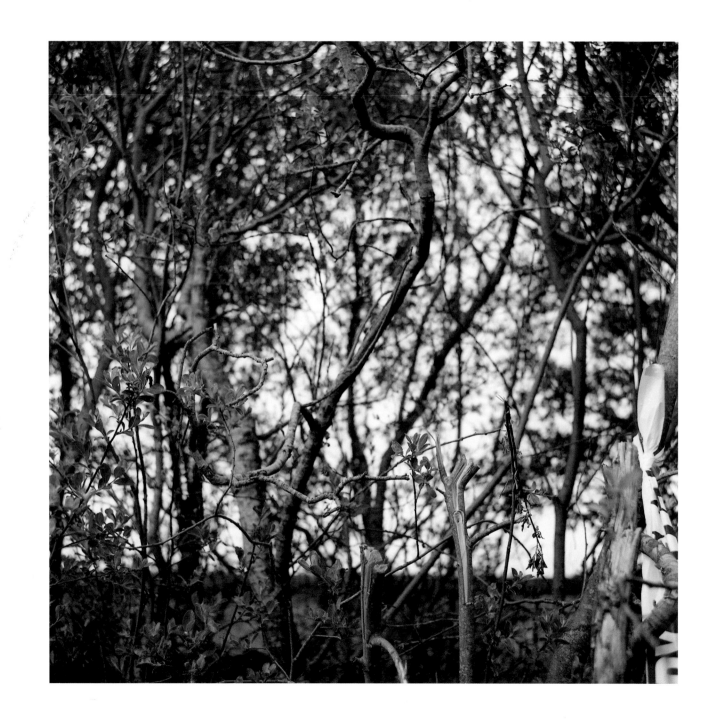

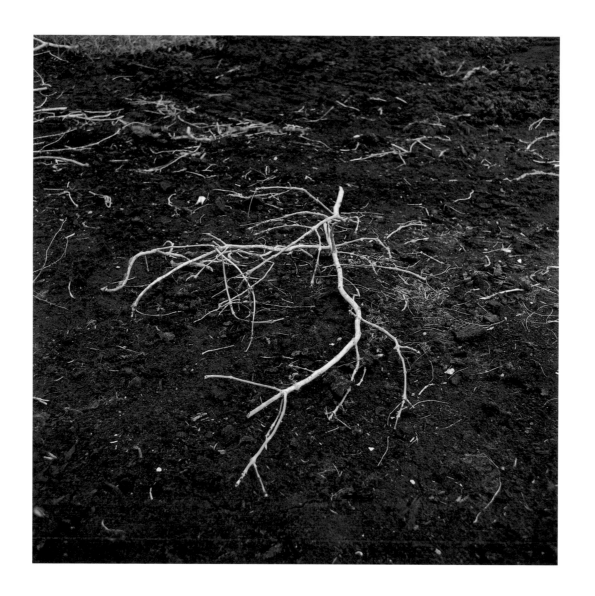

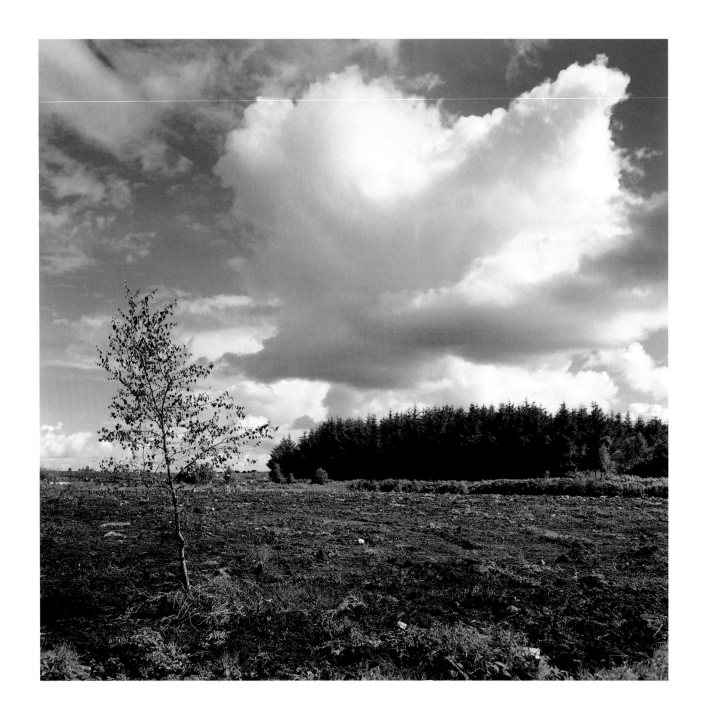

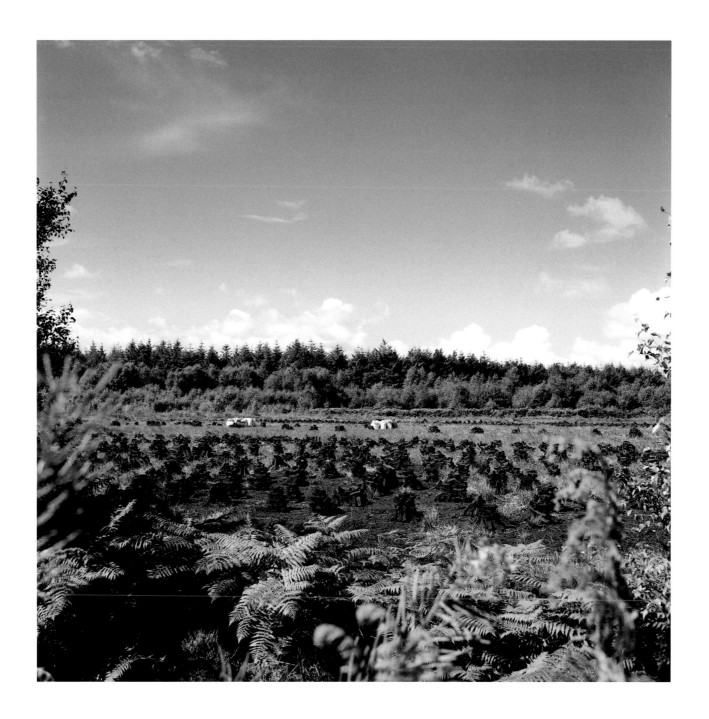

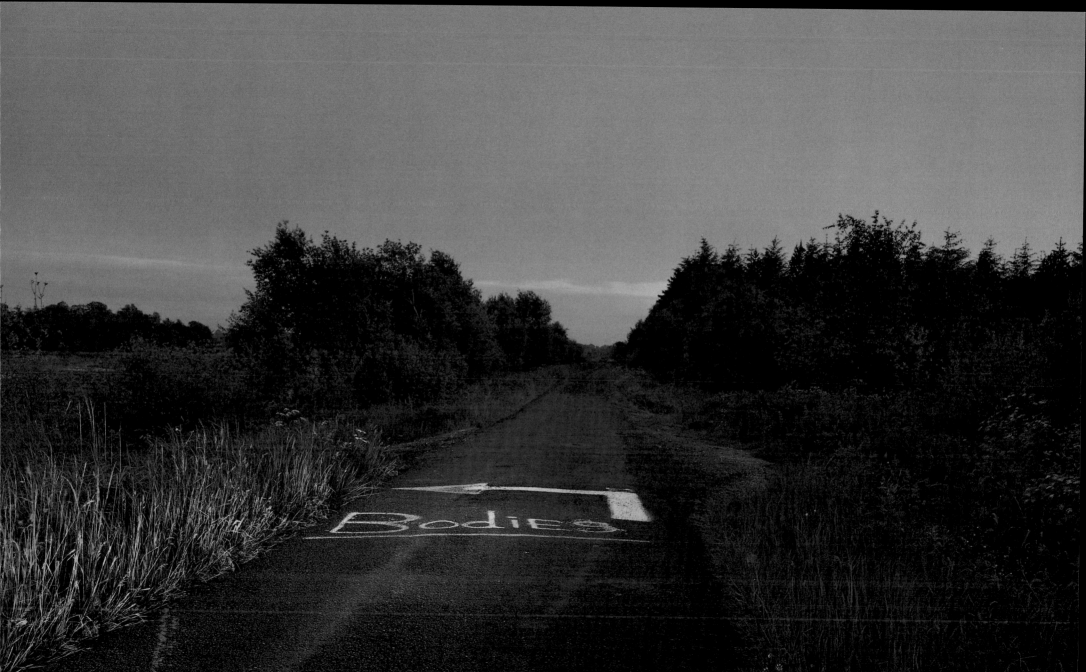

TEMPLETOWN

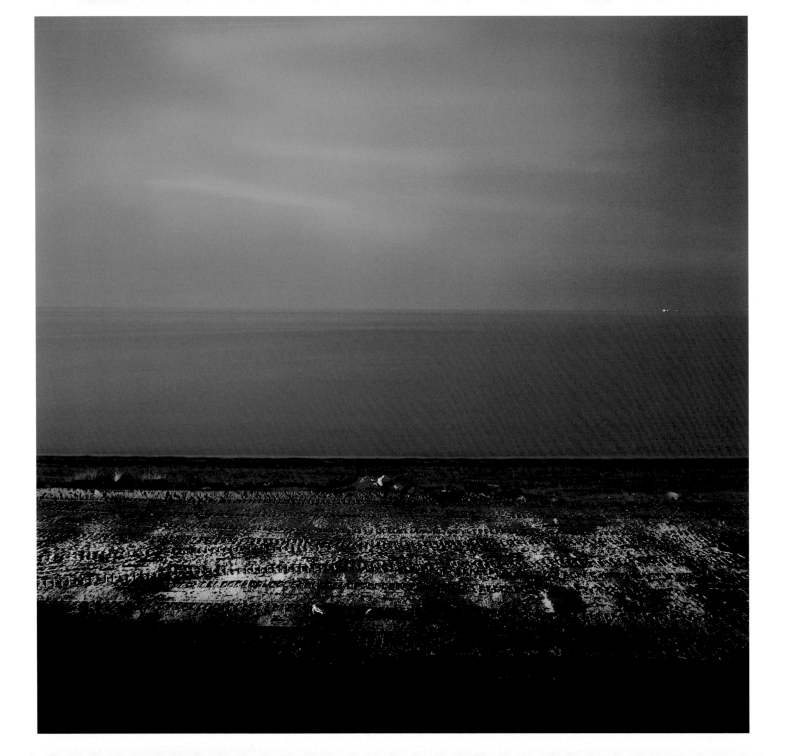

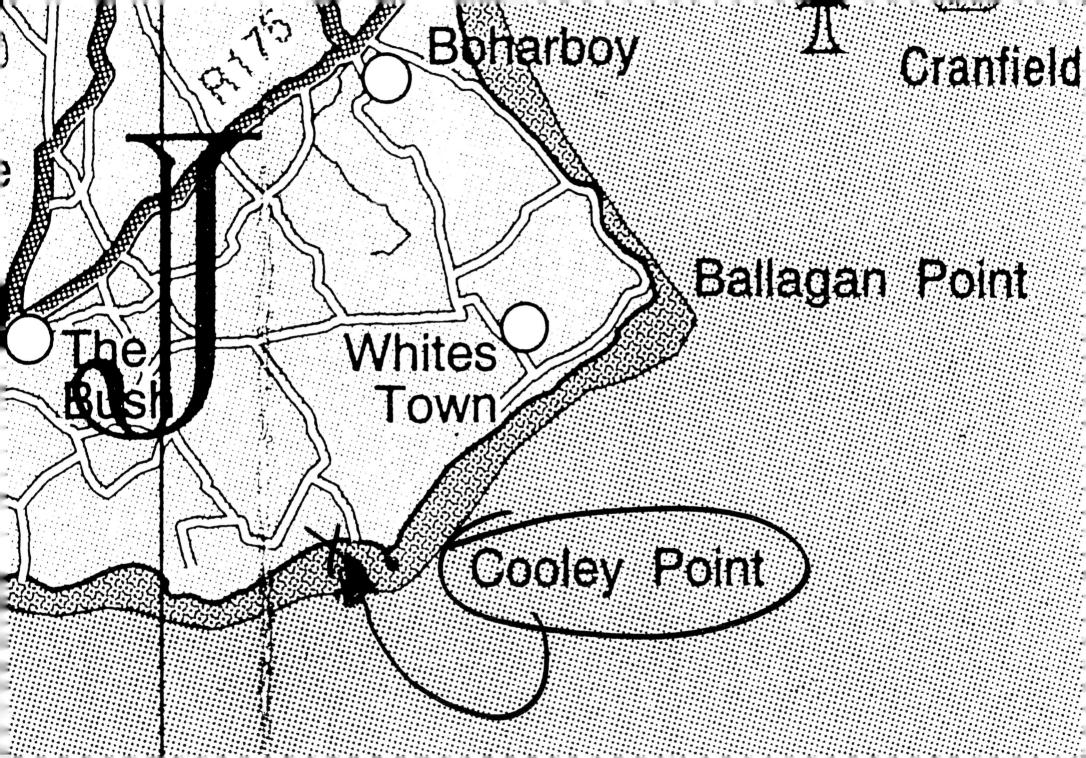

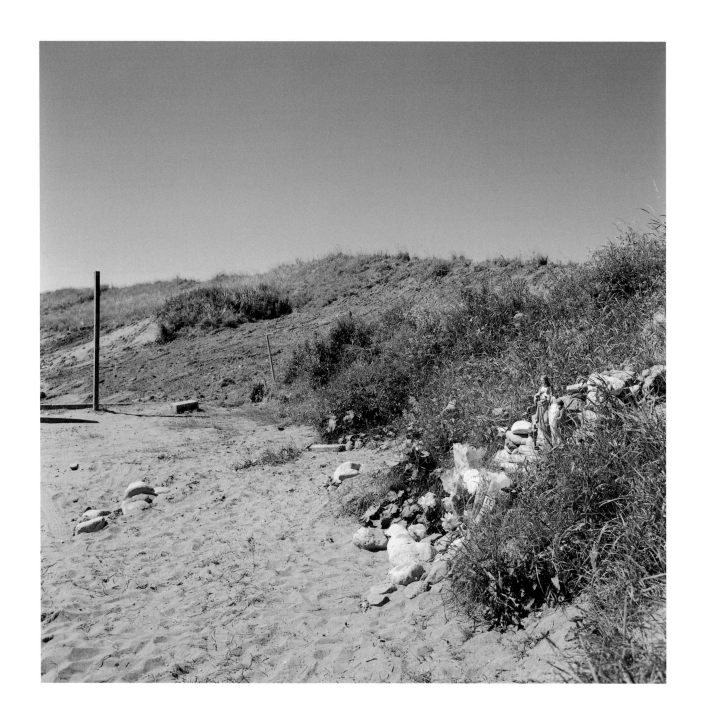

JEAN MCCONVILLE

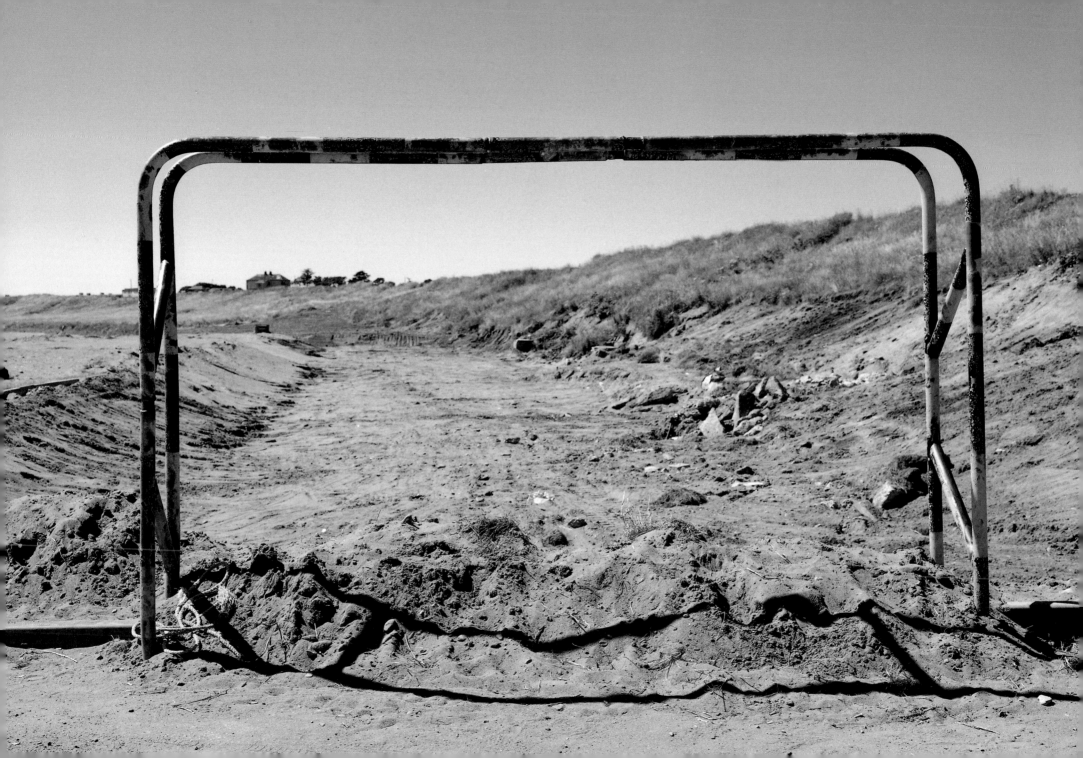

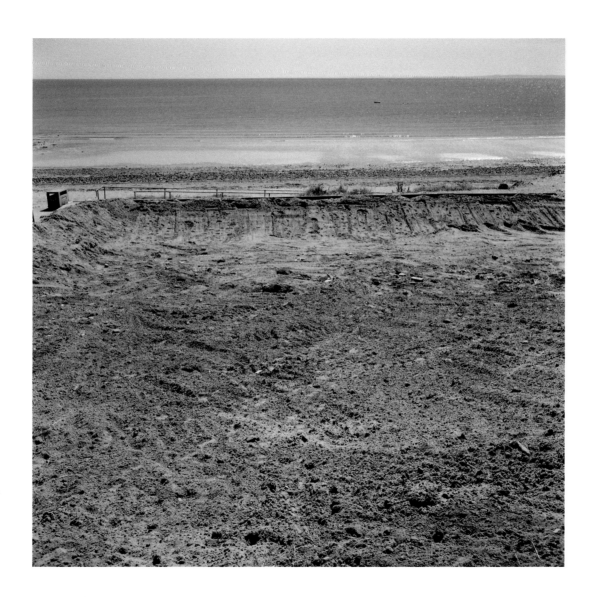

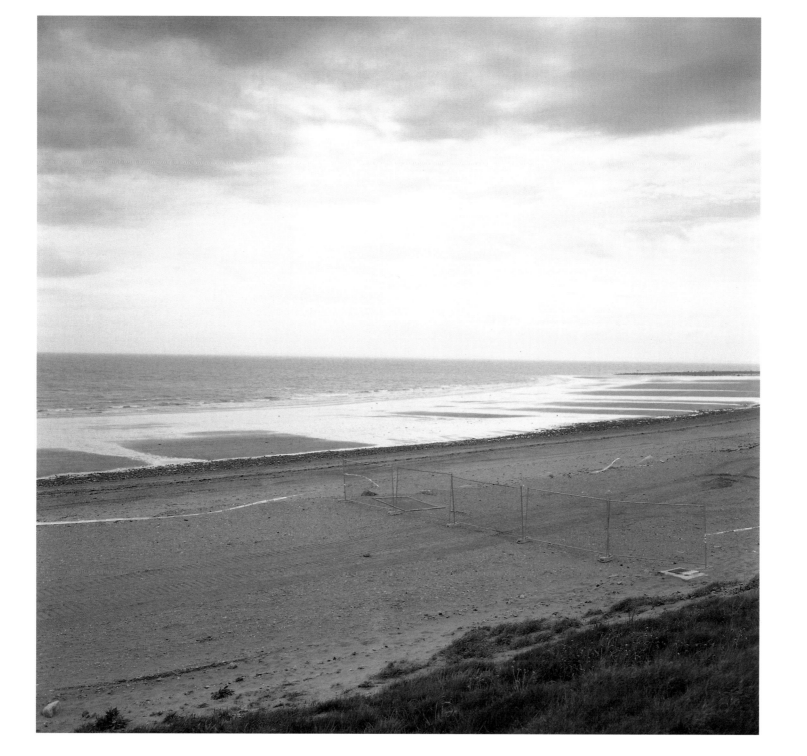

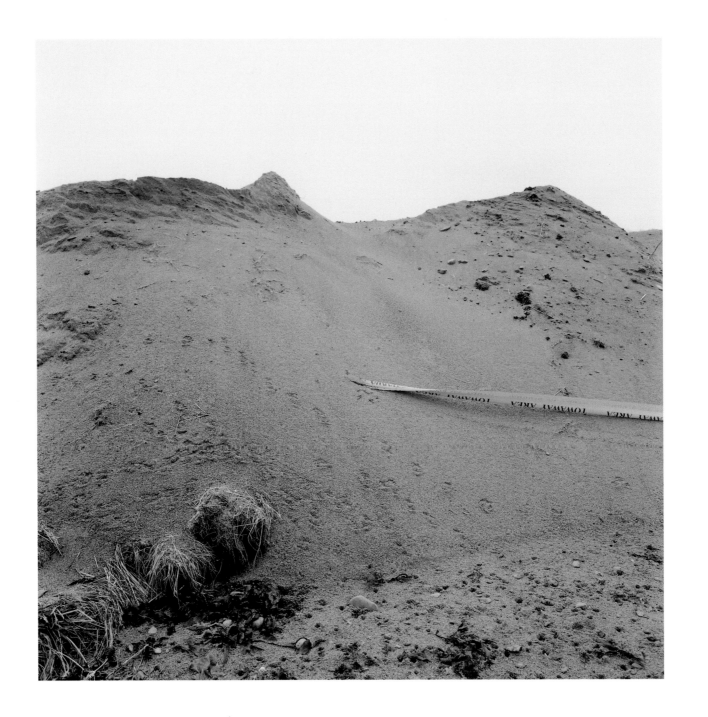

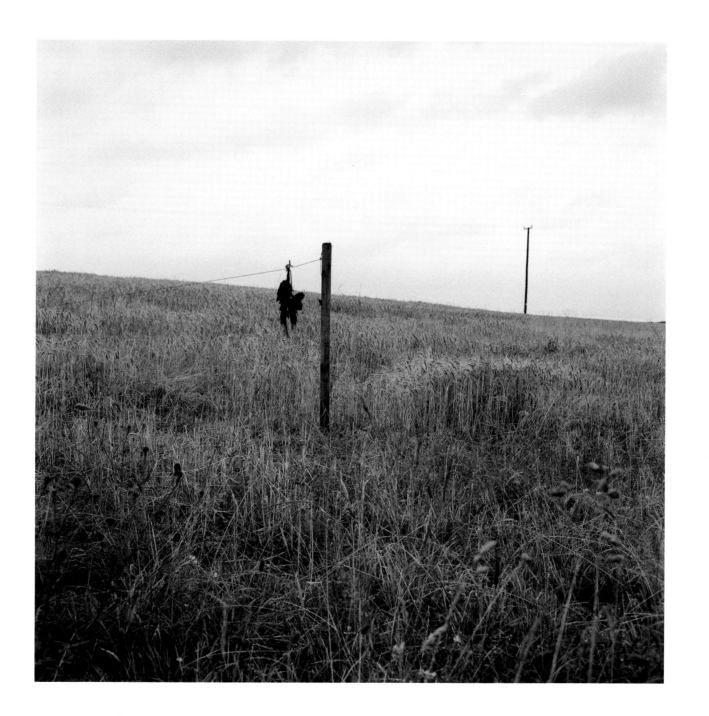

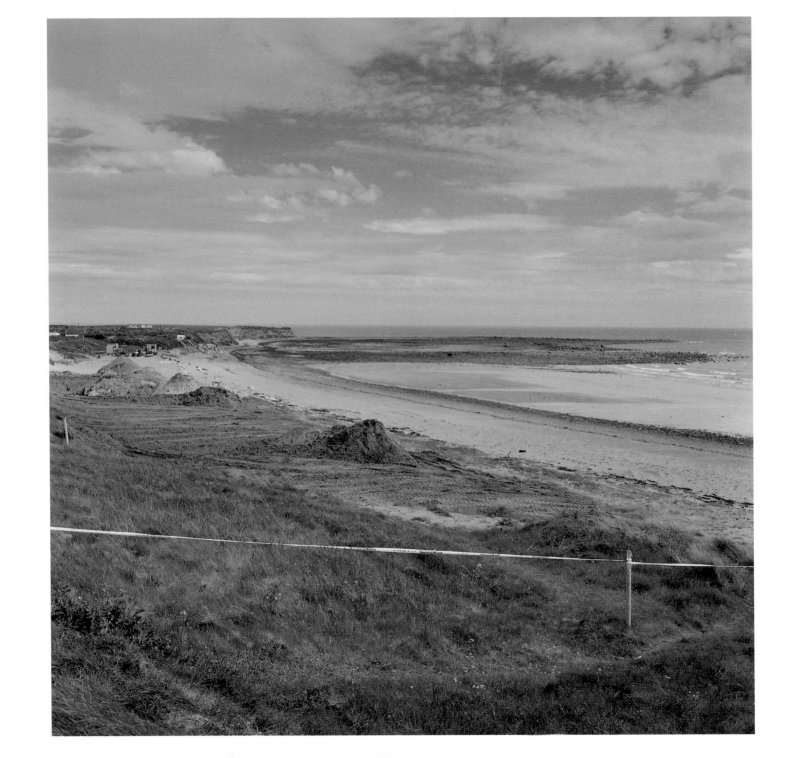

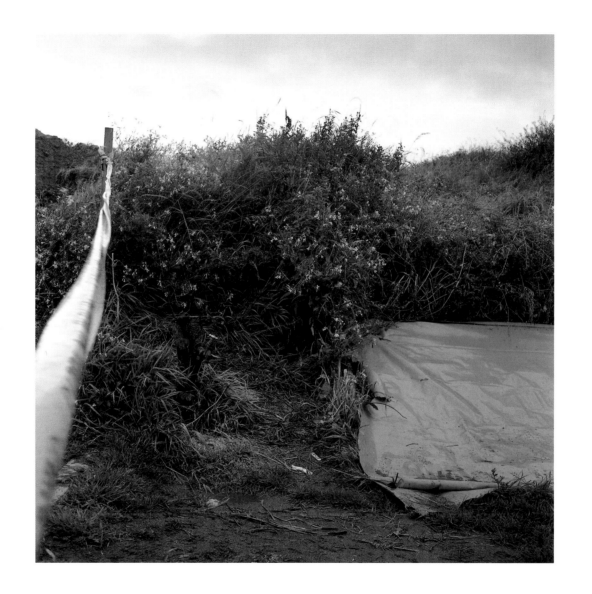

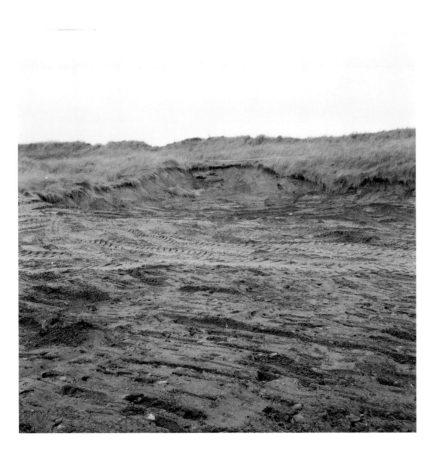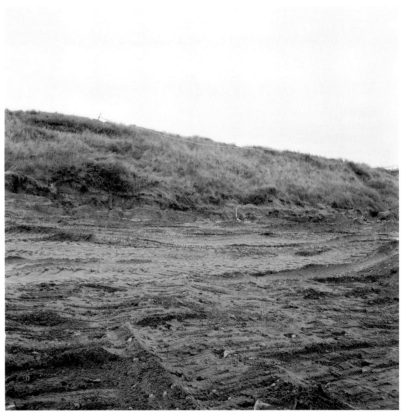

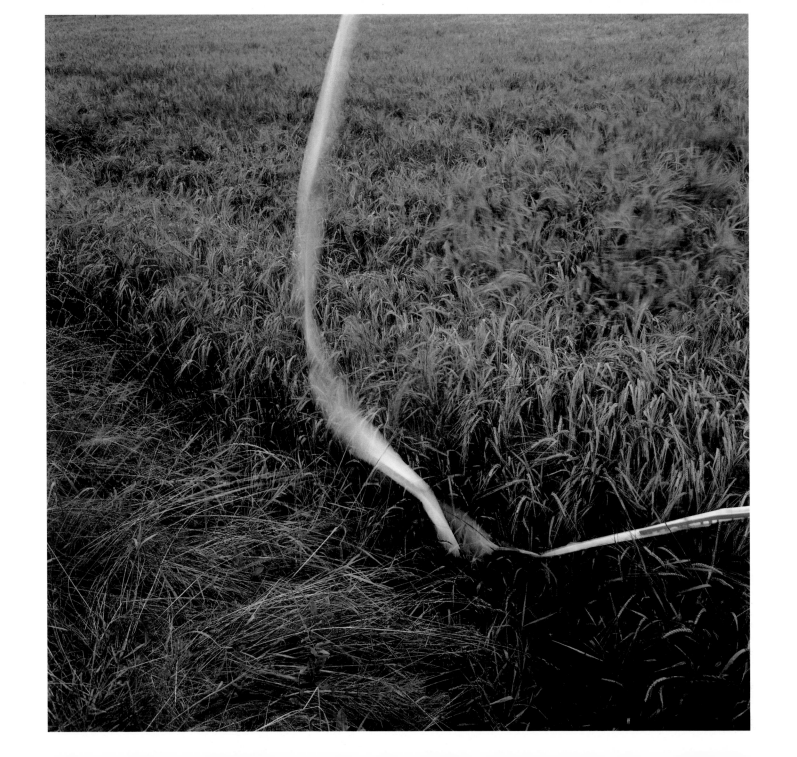

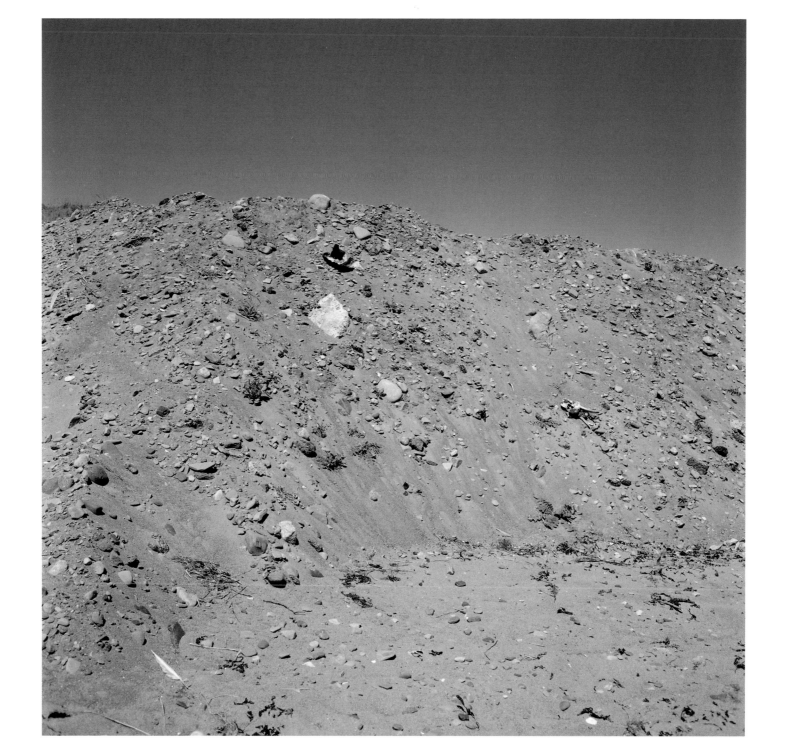

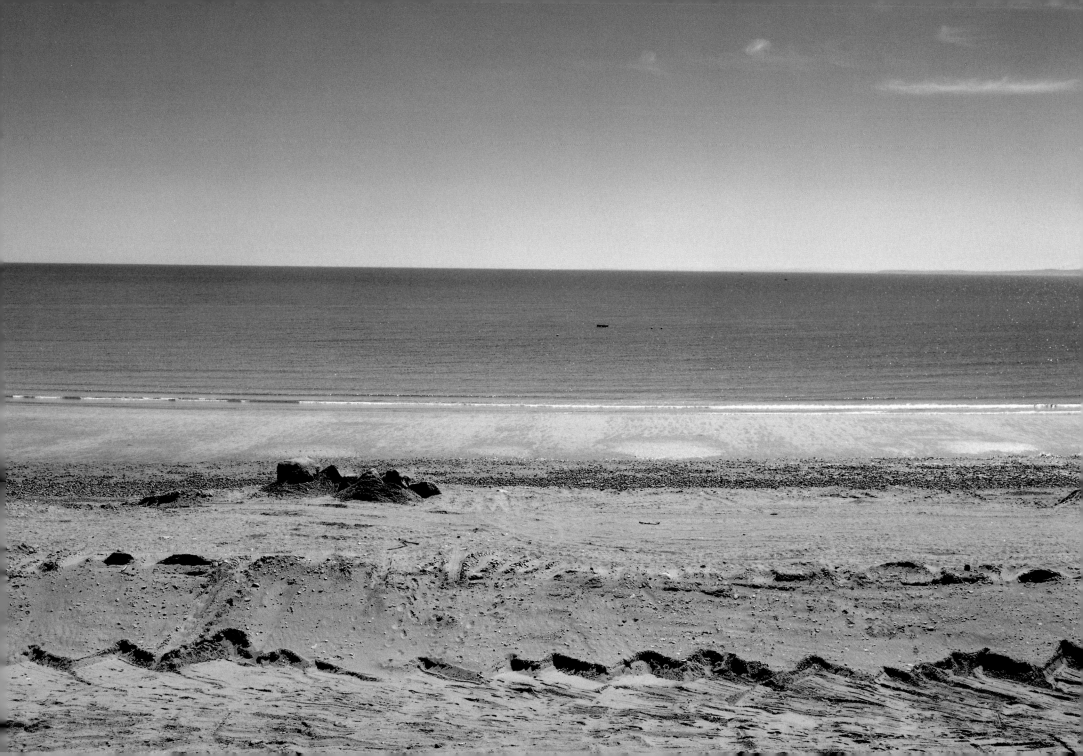

WILKINSTOWN

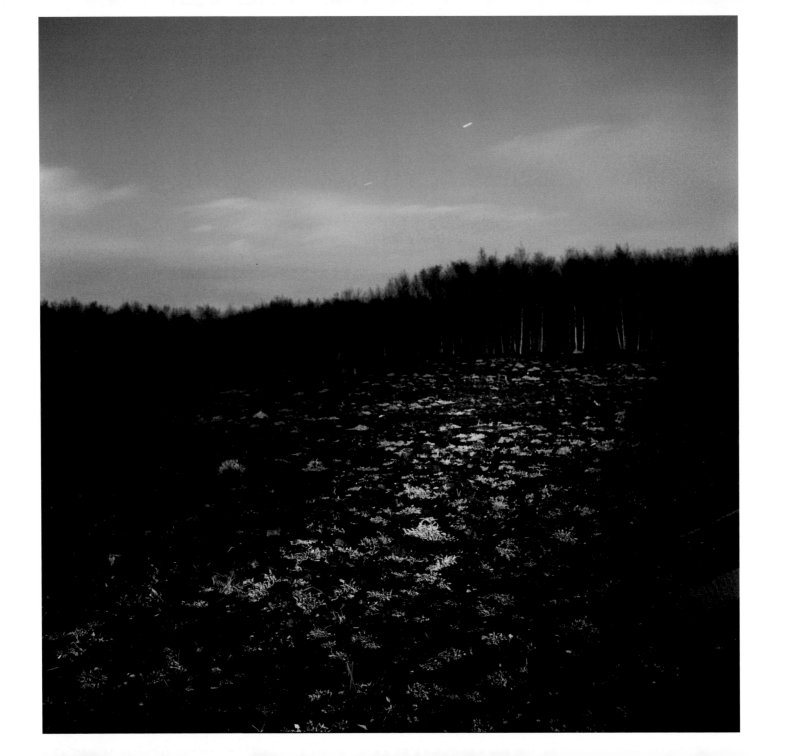

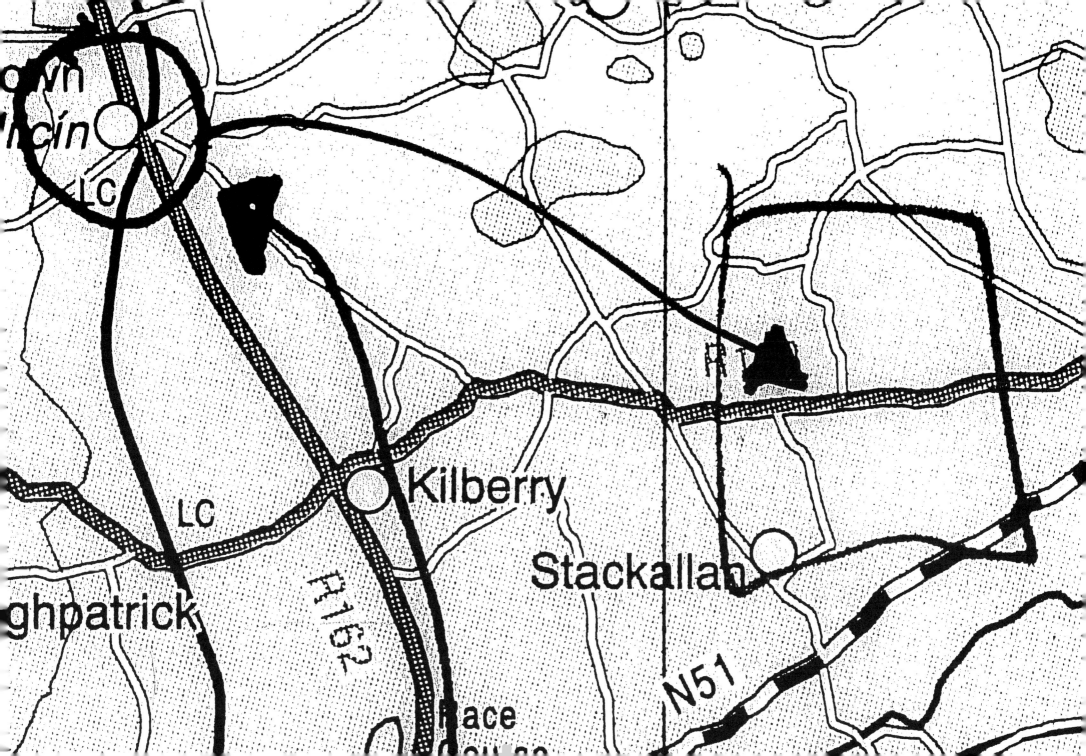

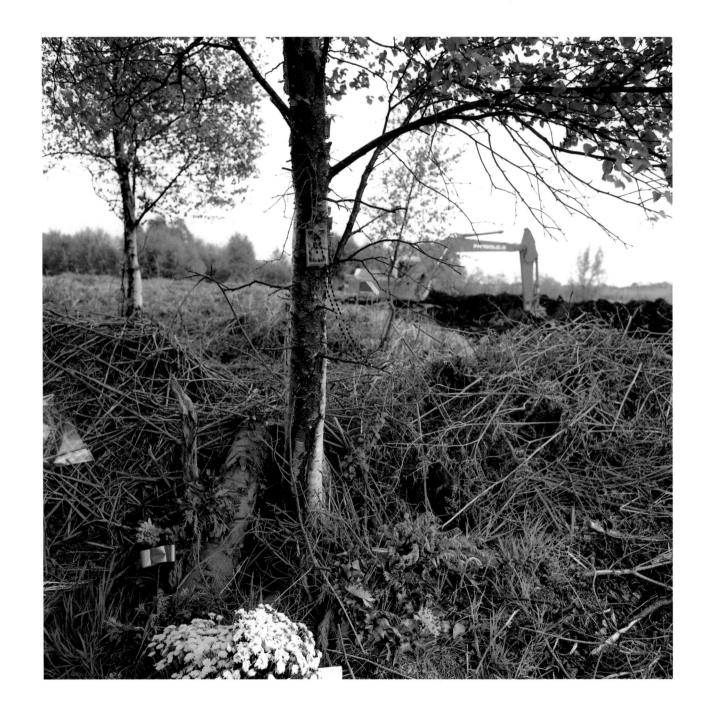

KEVIN MCKEE

SEAMUS WRIGHT

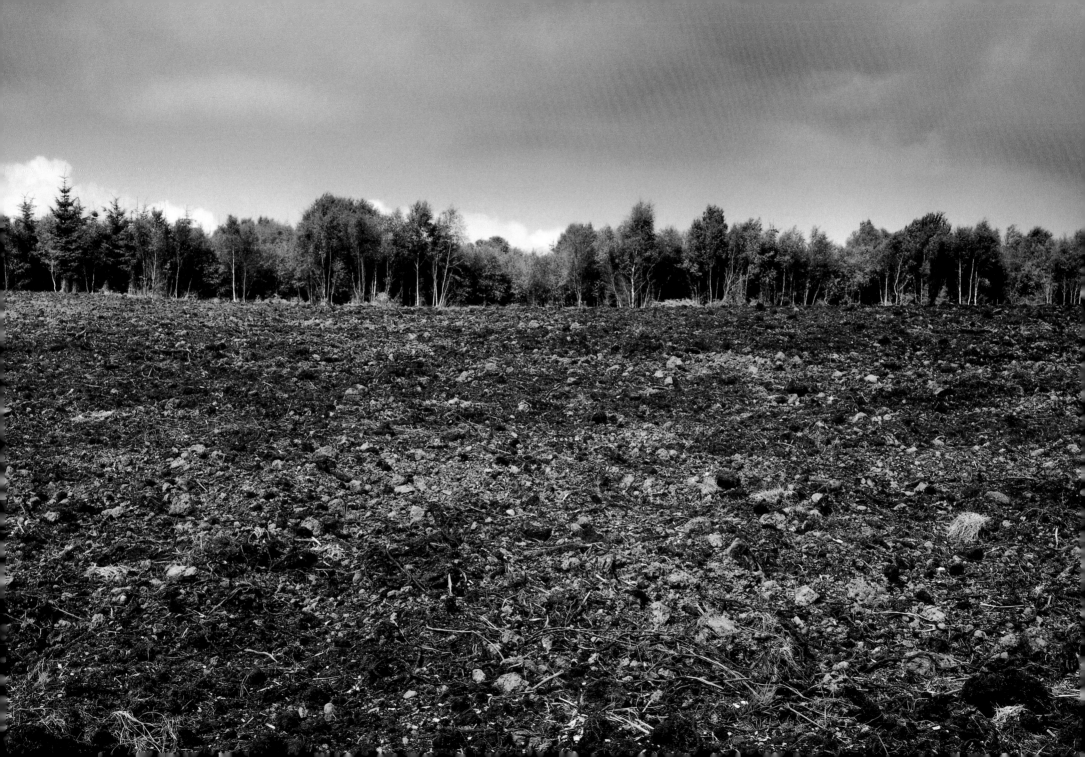

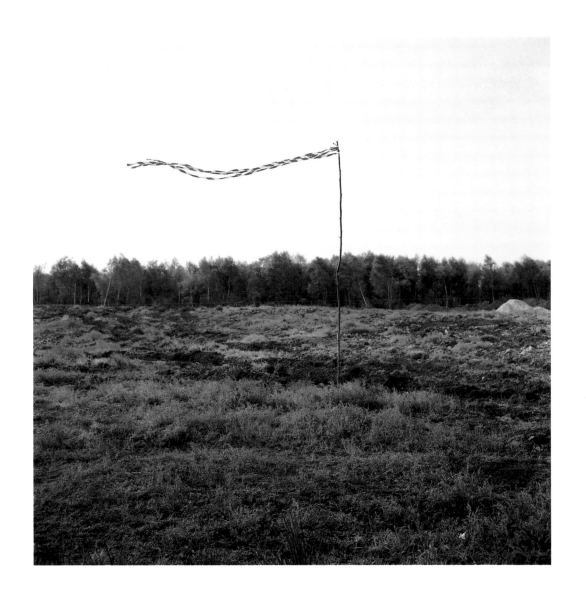

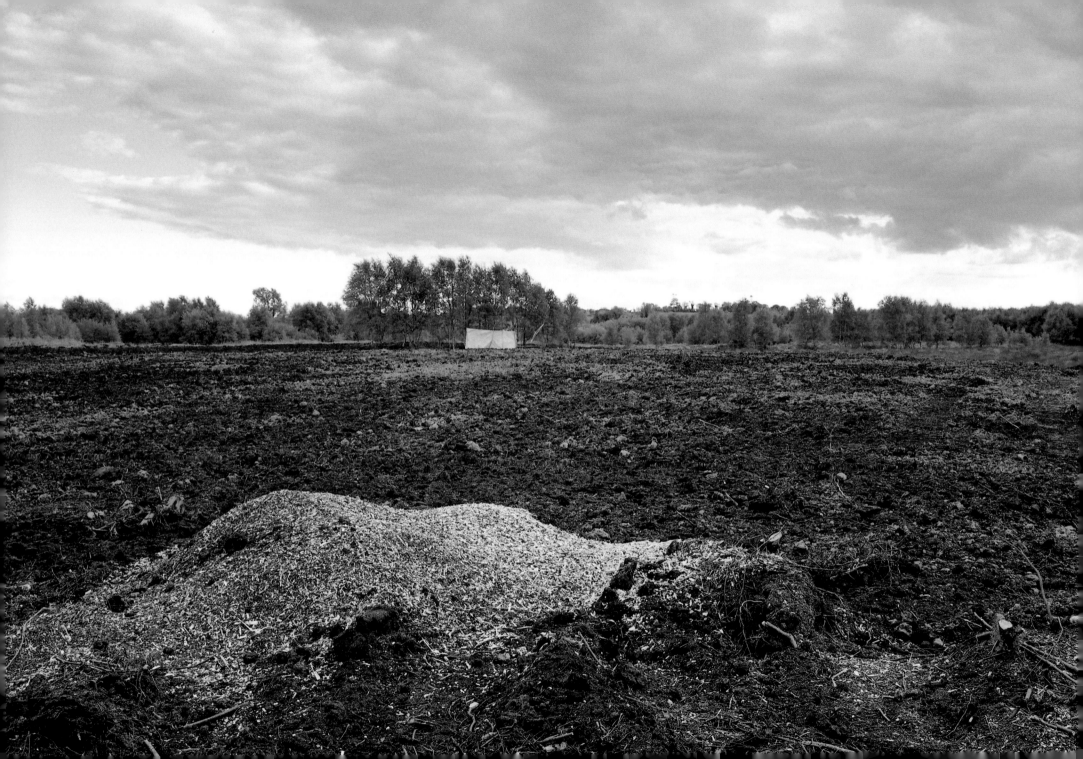

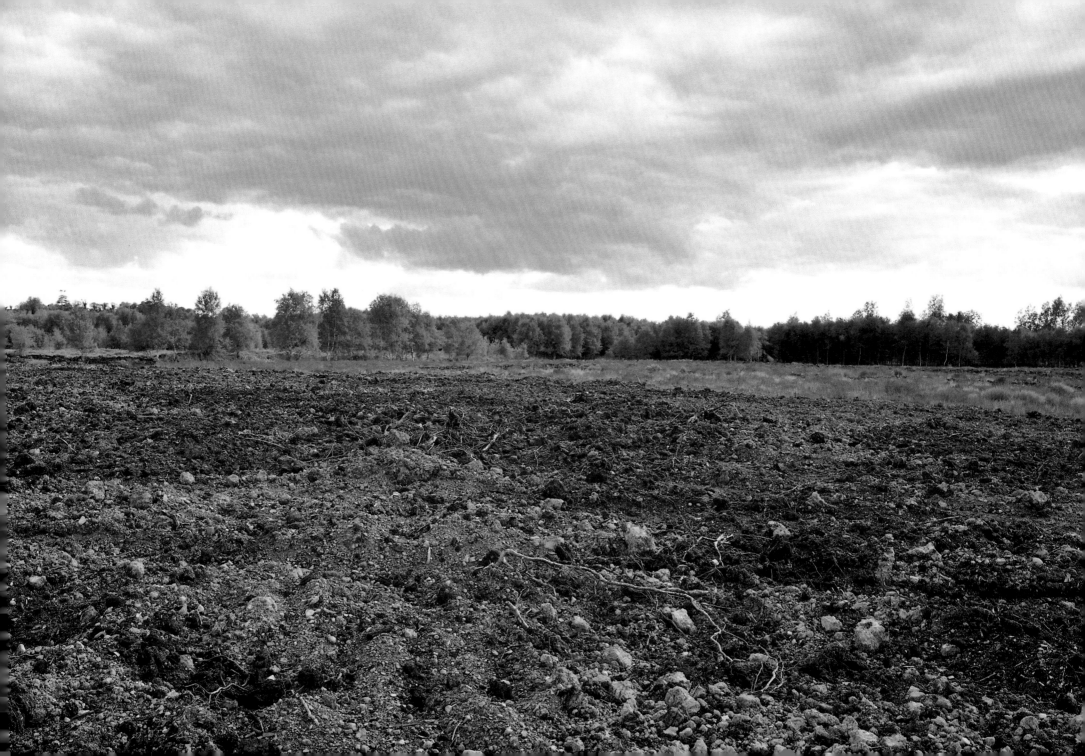

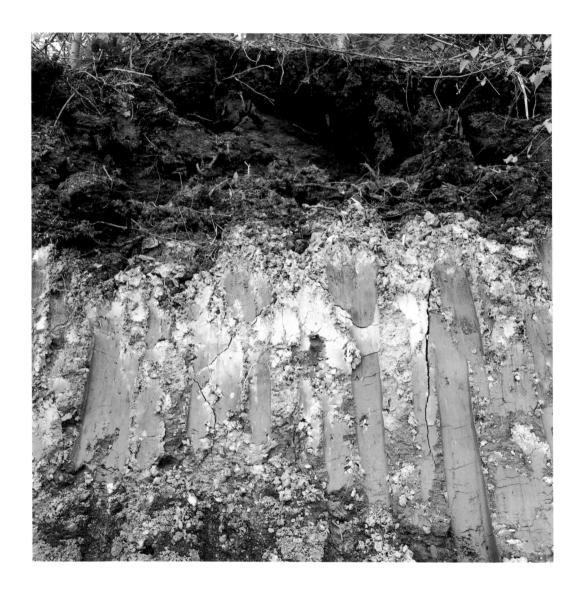

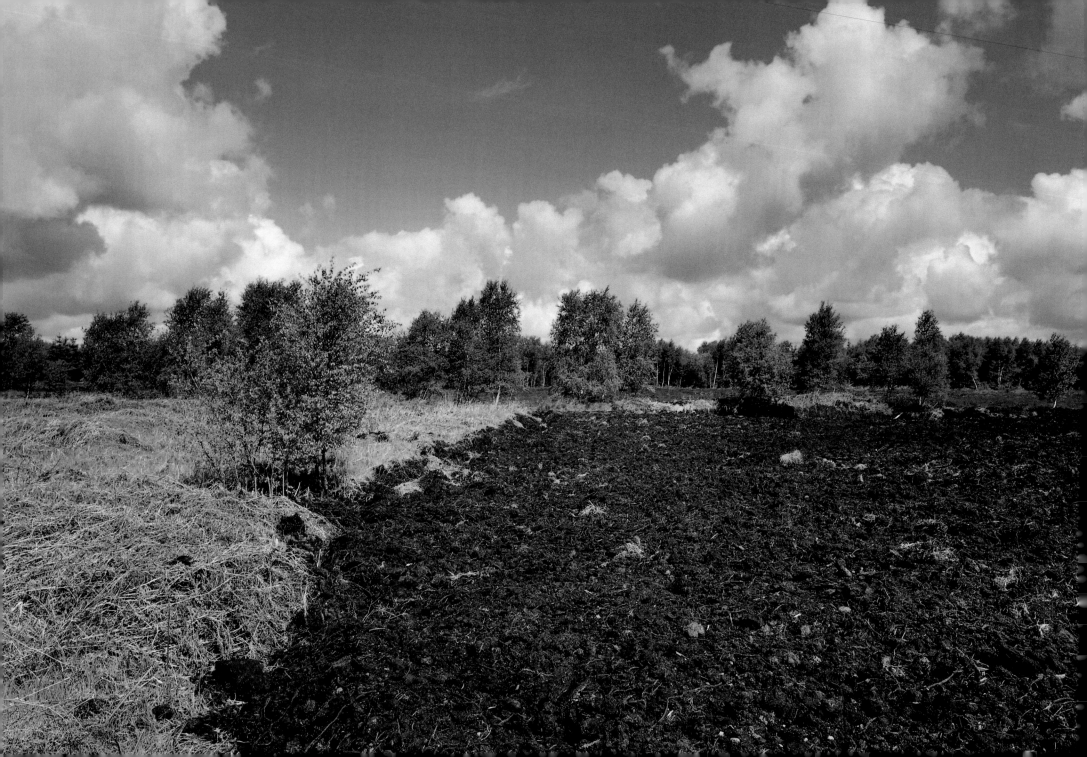

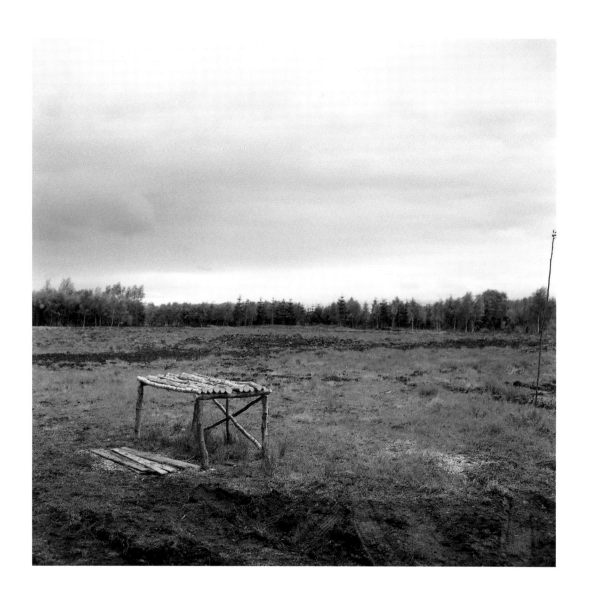

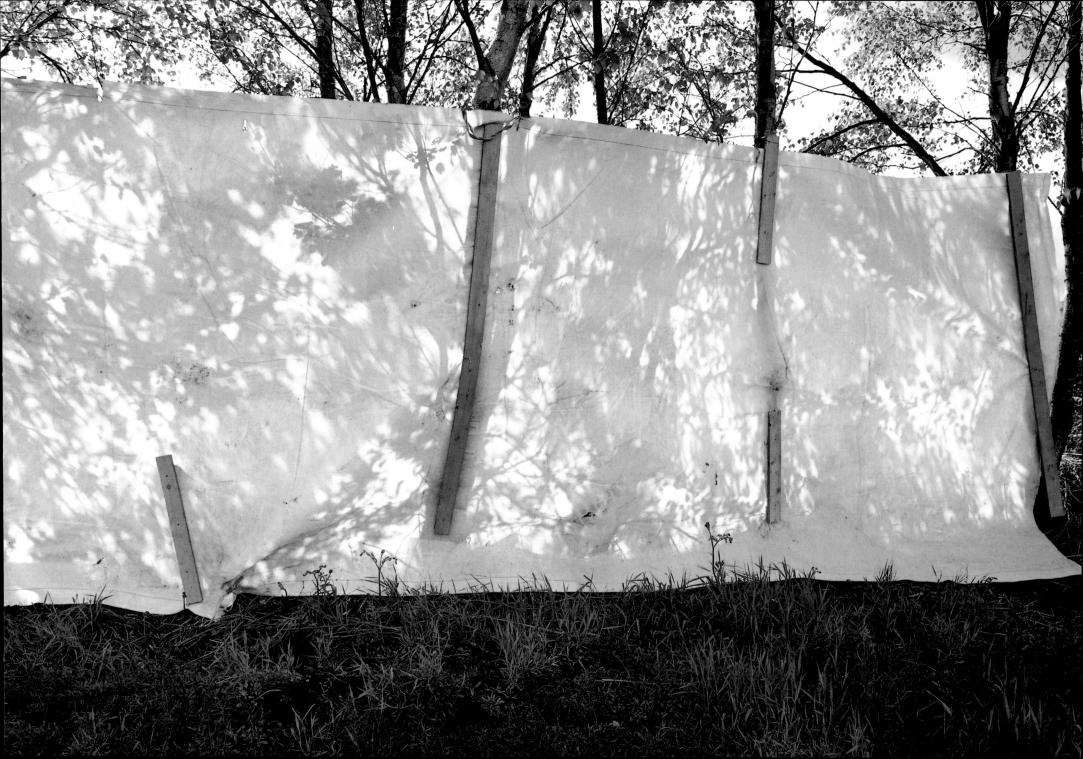

Bragan

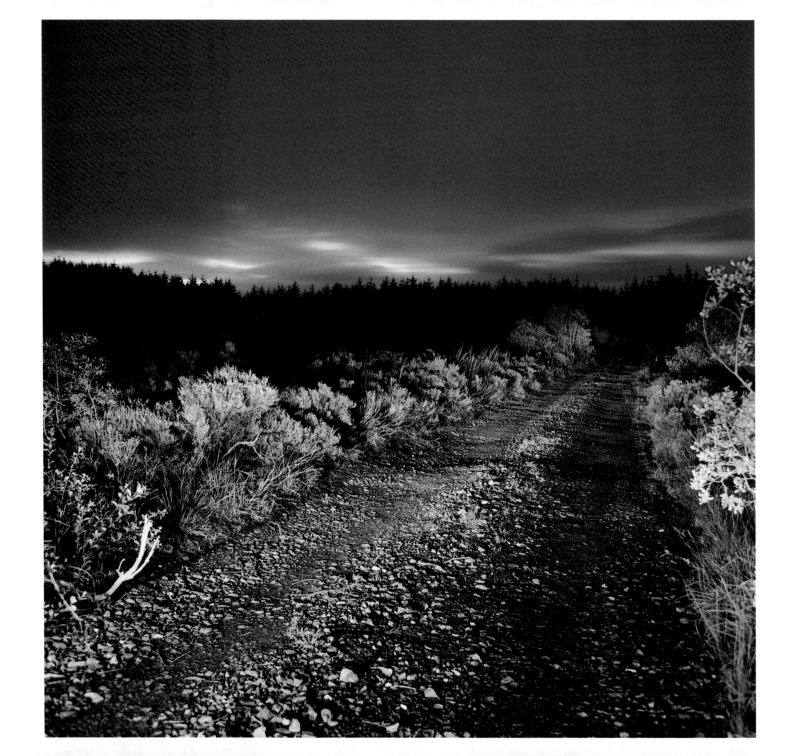

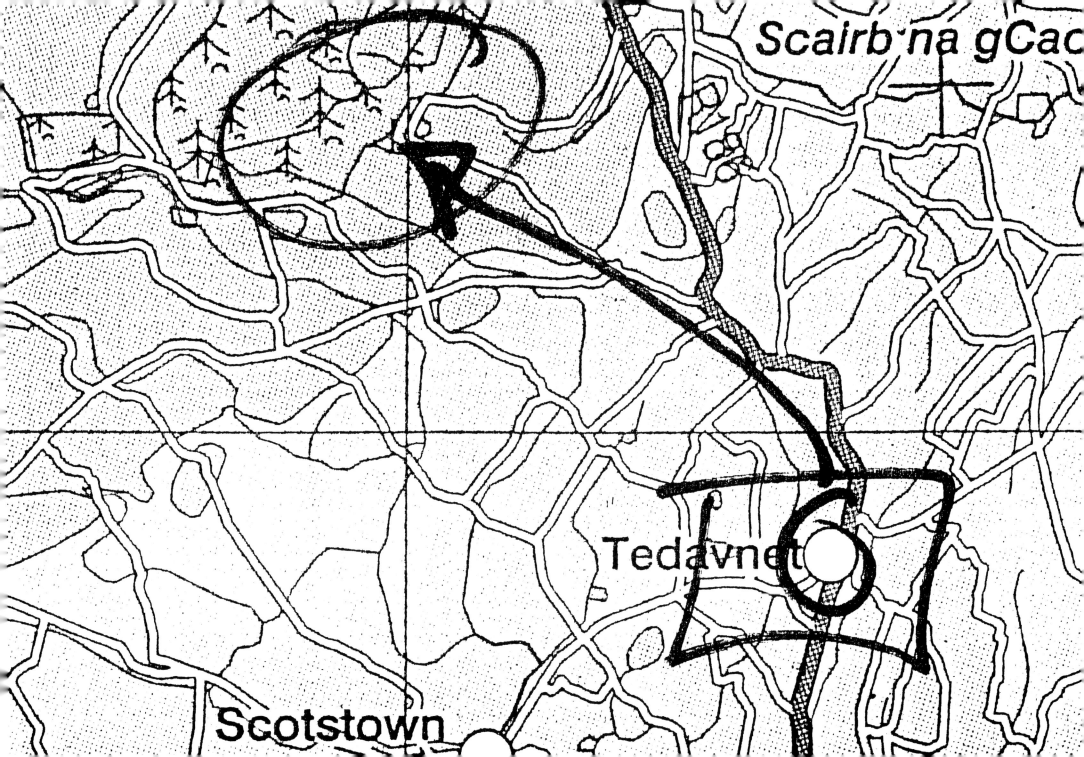

Scairb na gCac

Tedavnet

Scotstown

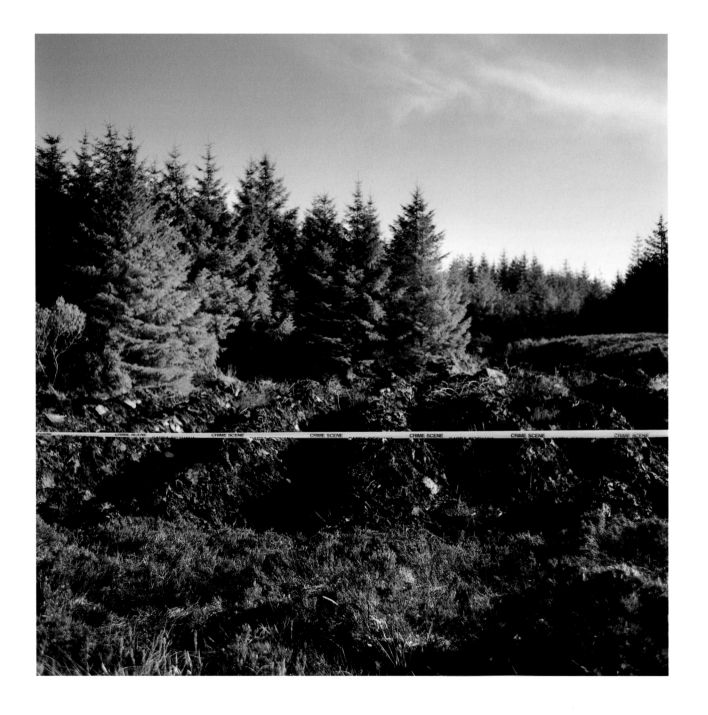

COLUMBA McVEIGH

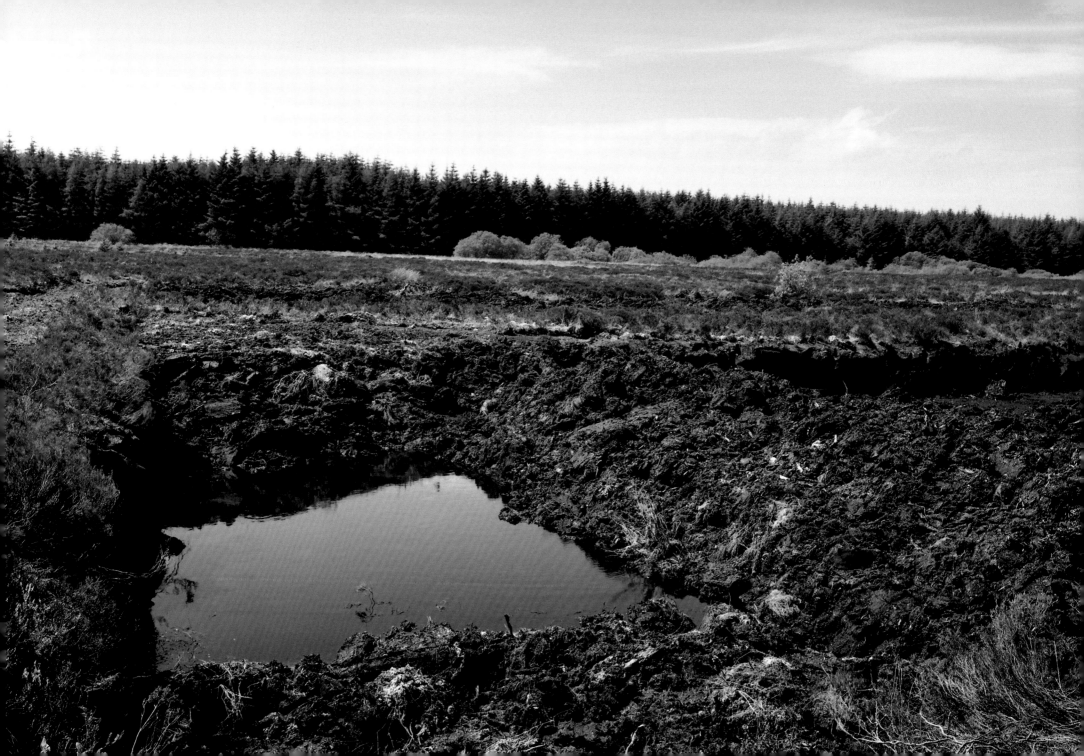

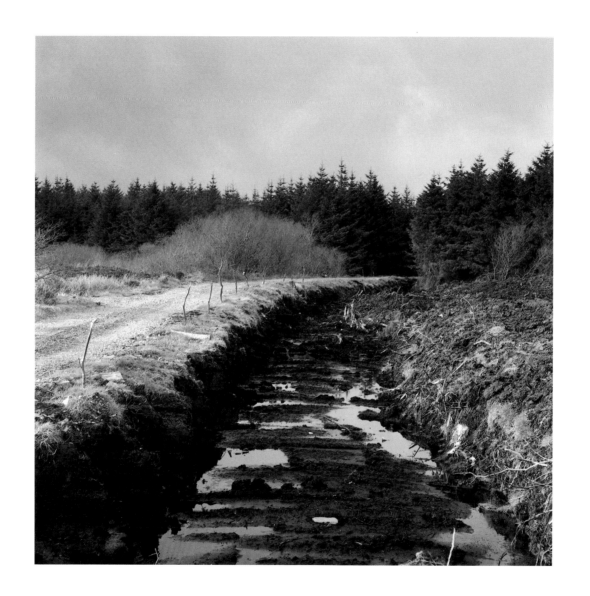

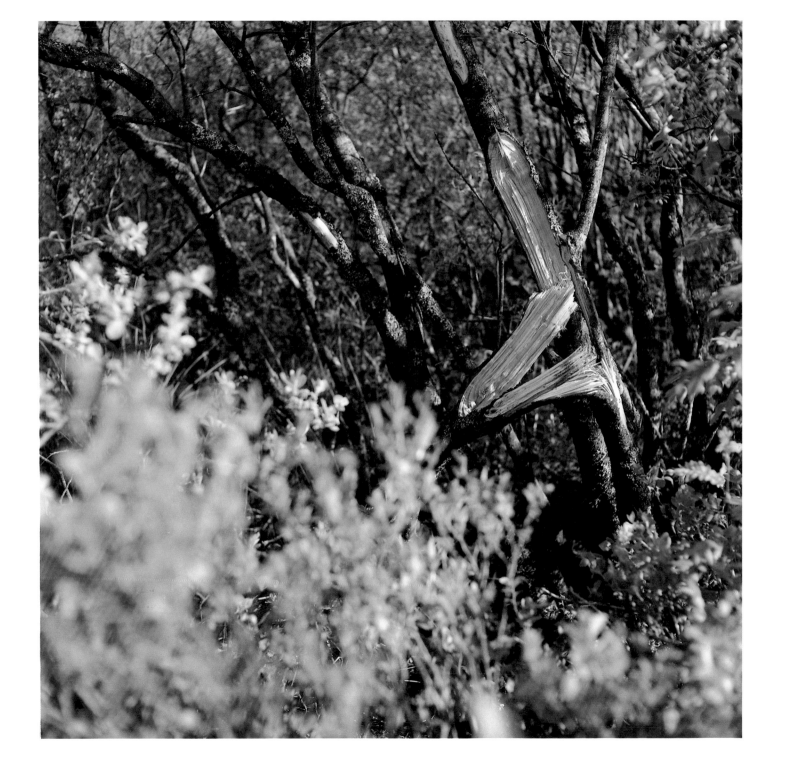

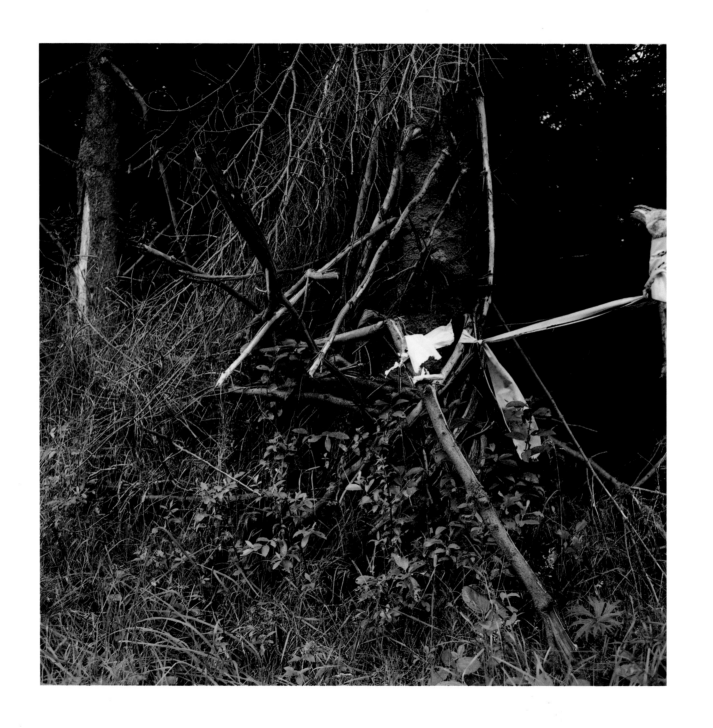

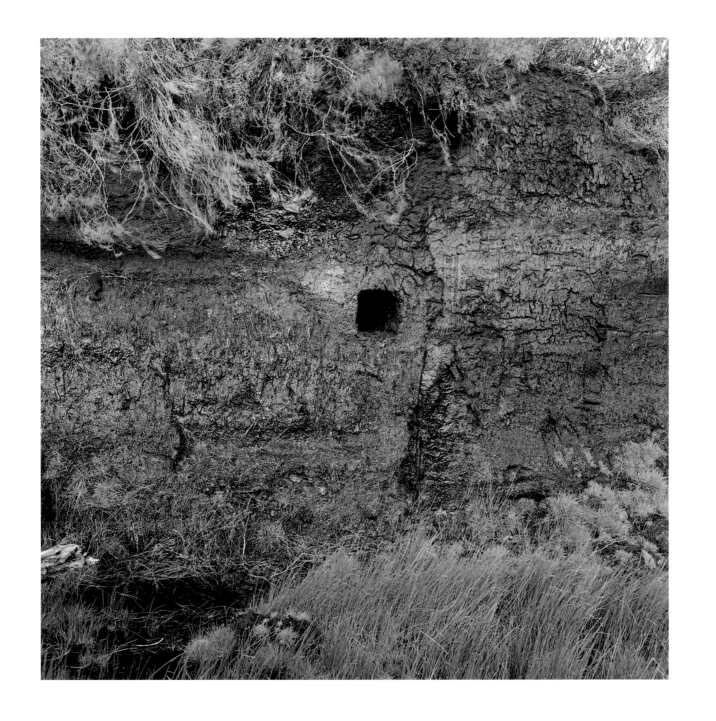

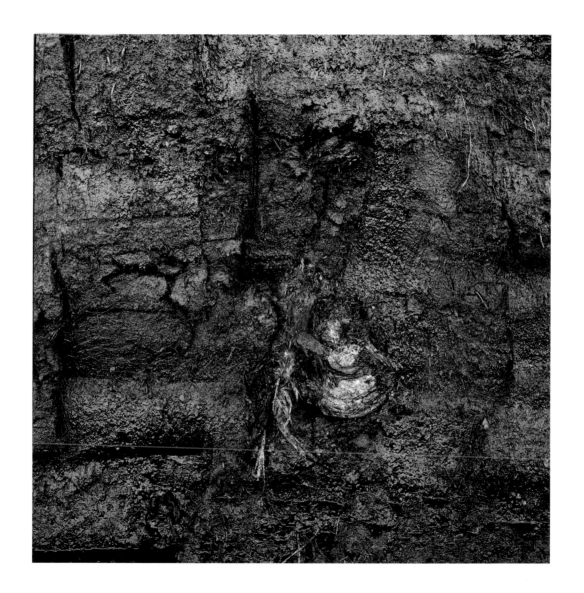

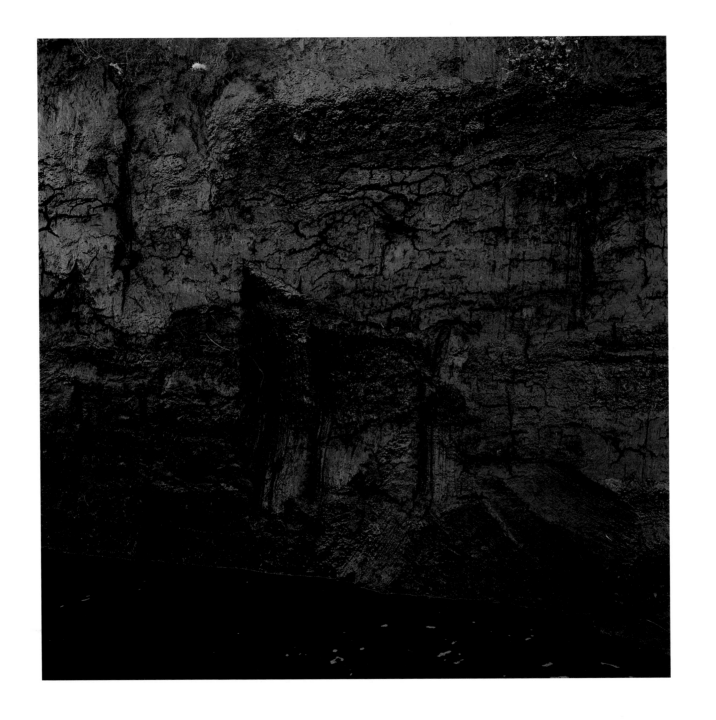

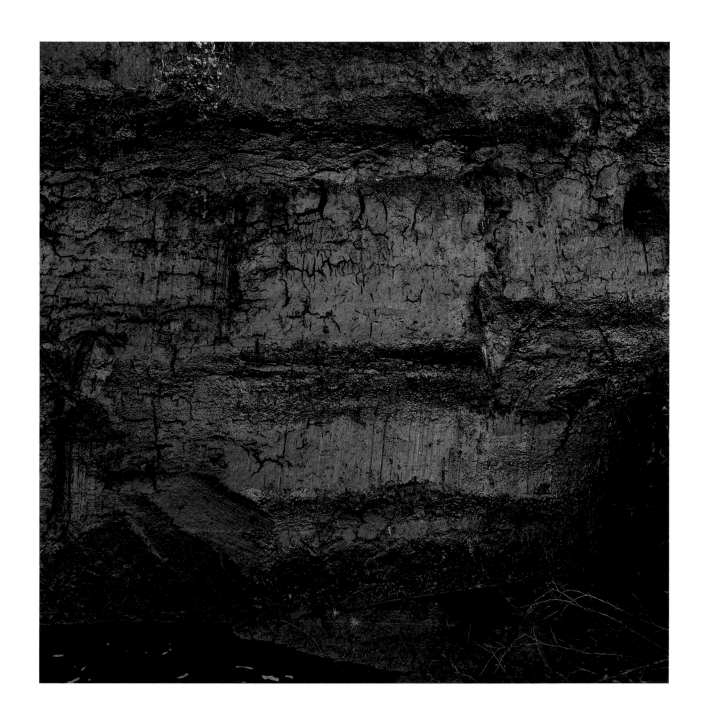

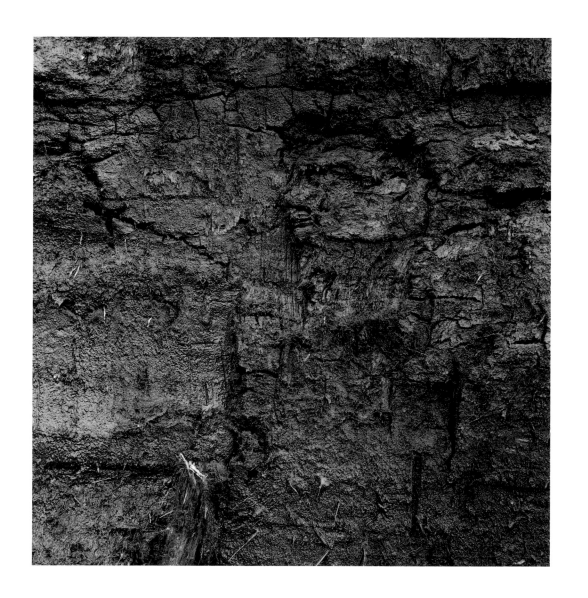

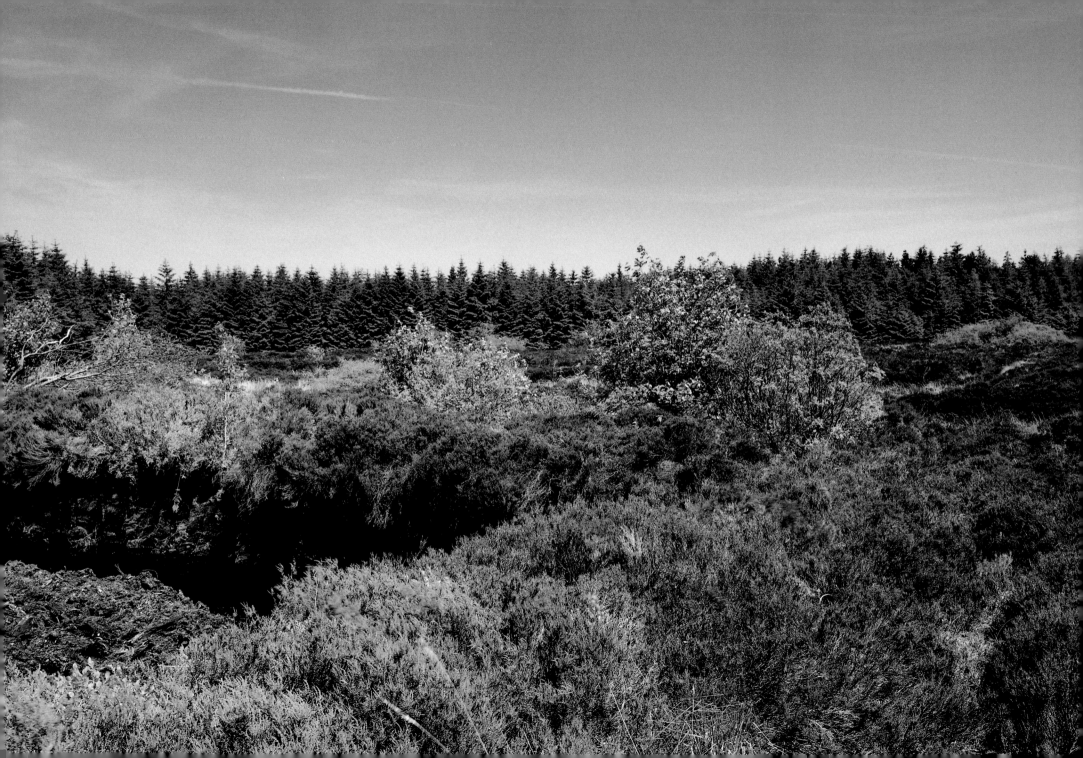

FAUGHART

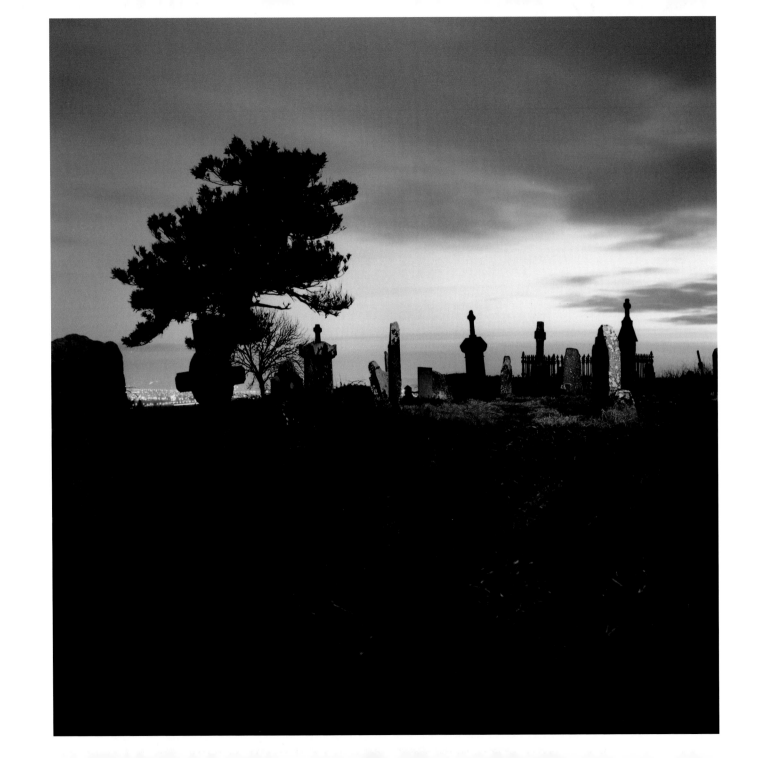

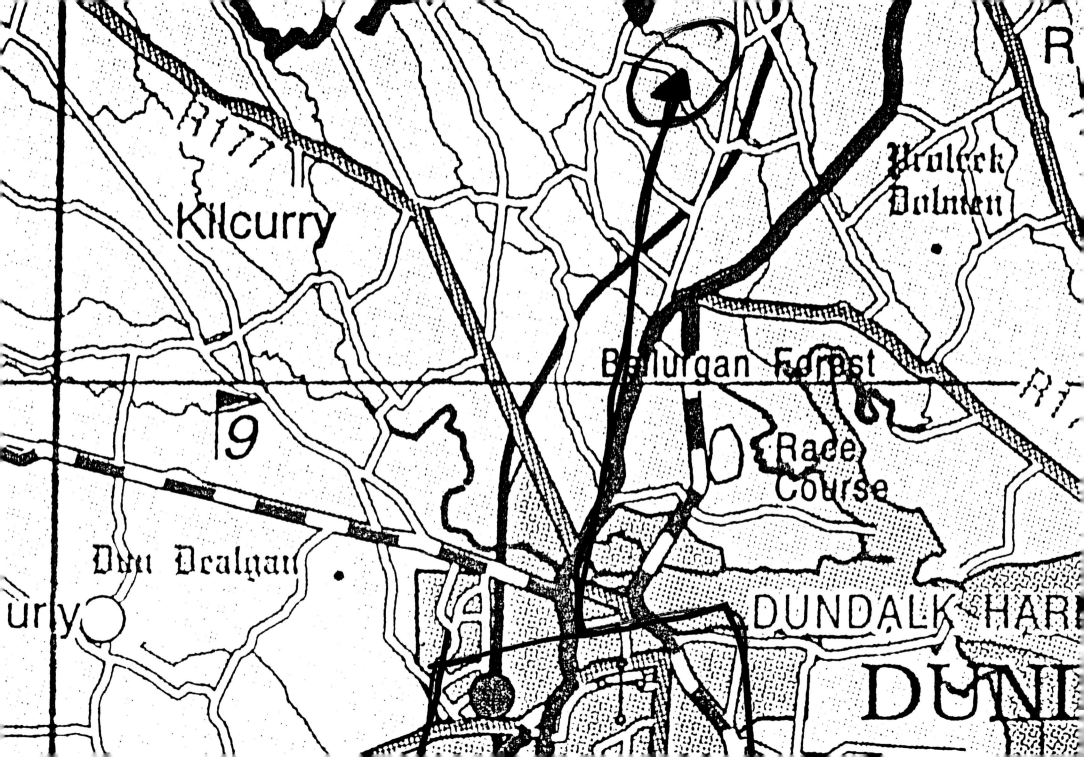

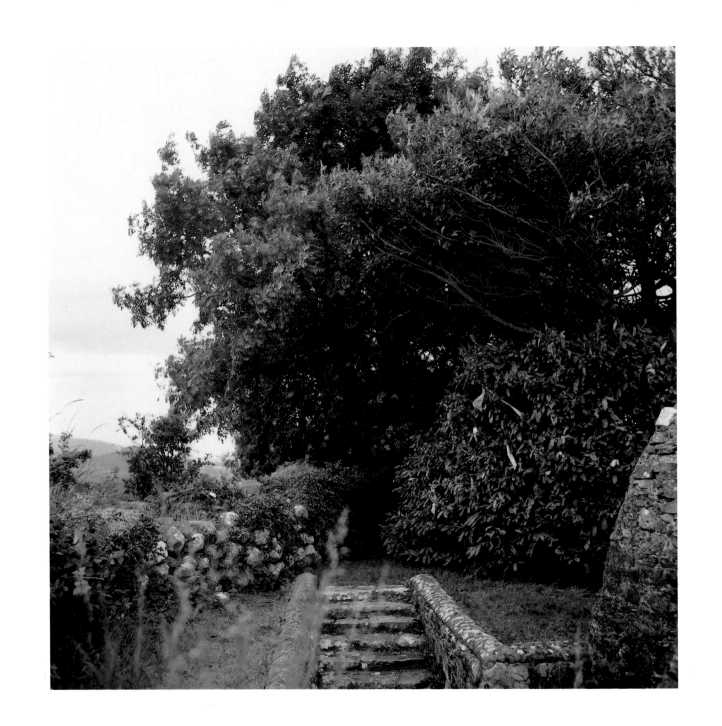

EAMONN MOLLOY

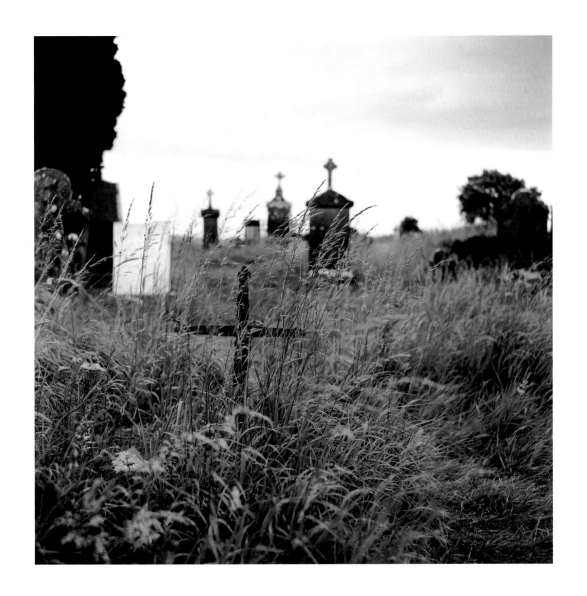

THE DISAPPEARED — A BRIEF HISTORY

In the thirty years of Northern Ireland's conflict and atrocity a small group of people stood apart: they were the 'missing', the 'disappeared' – absent and yet somehow still present. Even their exact number was uncertain though it was thought that there were at least fifteen people whose whereabouts had remained shrouded in misinformation and doubt since the 1970s and early 1980s.

Apart from Captain Robert Nairac, an undercover British soldier, they were all Catholic and widely assumed to have been 'disappeared' by the IRA in the process of internal 'policing' of the movement and the wider catholic community. Their families believed and hoped otherwise; there had been reported sightings at airports; postcards from other countries; stories of hope of all sorts had circulated. And there was also the knowledge that normally when people were 'policed' their body would be found shortly afterwards. But with this group there had been silence and perhaps most importantly, denial.

The Peace Process changed all of this, bringing the Republican movement under severe political pressure to resolve the issue. On 29th March 1999 the IRA issued a statement in which they apologised, accepting responsibility for the "injustice of prolonging the suffering of victim's families" and admitting to the "killing and secret burial" of ten people. Despite their own internal efforts though they had only managed to locate the graves of nine of the victims which they would announce as soon as some form of immunity from prosecution had been secured.

The Northern Ireland Location of Victims Remains Bill was passed in the House of Commons on May 27th 1999; it provided an amnesty for people to come forward with information to identify and locate what became known as the 'Sites of The Disappeared'. The next day the remains of Eamonn Molloy – 21 years old when he disappeared in 1975 – were retrieved in a recently purchased coffin above ground in the corner of an old cemetery in Faughart Co. Louth. The following day the locations of six sites, said to be the burial places of eight people, were announced and the search of the landscape began.

It now seemed as if some comfort would at last be afforded to the families of all those confirmed as 'disappeared':

Kevin McKee and Seamus Wright, disappeared 1972
Jean McConville, 39 years old widow and mother of ten children, disappeared 1972
Columba McVeigh, 17 years old, disappeared 1975
Eamonn Molloy, 21 years old disappeared 1975
Brendan Megraw, 24 years old, disappeared 1978
Brian McKinney, 22 years old and John McClory, 17 years old, disappeared 1978
Danny McIlhone, early twenties, disappeared 1981.

The searches began slowly and carefully using shovels and wheelbarrows. There was great concern to maintain the dignity of these final

arrangements. Optimism was high – there had been the return of Eamonn Molloy; a small yellow flag appeared to indicate an exact location at Ballynultagh, an isolated Co. Wicklow hillside; and at a beachside car park in Templetown, Co. Louth there was precise detail concerning a specific parking bay. The directions for the remaining locations were less clear and with hindsight probably indicated what lay ahead: a 100 sq. metre area at Coghalstown Wood, Wilkinstown; 400 sq. metres at Oristown, Co. Meath; 30 sq. metres at Colgagh and a 3,000 sq. metre area of extremely wet bogland at Bragan, Co. Monaghan. At one site the directions were in the form of a series of clues – the tree with the broken branch from which a specific number of steps could be taken across a bog to another tree with a broken branch and so on. These instructions were somewhat clouded by the fact that the tree was not old enough to have been present as a landmark all those years ago. Despite this, the families were reassured that the information was genuine and sincere.

Within days, however, shovels had been replaced by mechanical diggers and ground-penetrating radar equipment which allowed deeper and more substantial incisions to be made. The soil from these large trenches was examined closely for any possible evidence. By now though confidence was slowly ebbing. Three weeks in, the searches at Oristown and Ballynultagh were suspended and the other sites were being reassessed. A breakthrough was needed.

It came on 29th June: the Gardai, who had been draining 50,000 gallons of water a day from the site at Colgagh, switched attention to an area at the opposite end of the field they had been searching. Here they found the double grave of Brian McKinney and John McClory. This brought a sad comfort to their parents, now in their late sixties. But it also gave impetus to continuing the remaining digs and a sense of reassurance that the initial information had at least been accurate.

Sadly, despite increased efforts, no further remains were found and on 17th July 1999 (the fiftieth day) the search was suspended. The families were left bewildered and bruised.

By September that year members of the IRA had revisited each site, new information had been provided and it was hoped that a fresh search might be instigated. However, the weather was changing and all thoughts of resumption were put on hold until 2nd May 2000, when Gardai began to search again at the remaining five sites. It was to no avail. Eighteen days later on 20th May the digs were halted, leaving six bewildered families looking across empty fields of memory and doubt. It is highly unlikely that the digs will ever start again.

David Farrell, May 2001

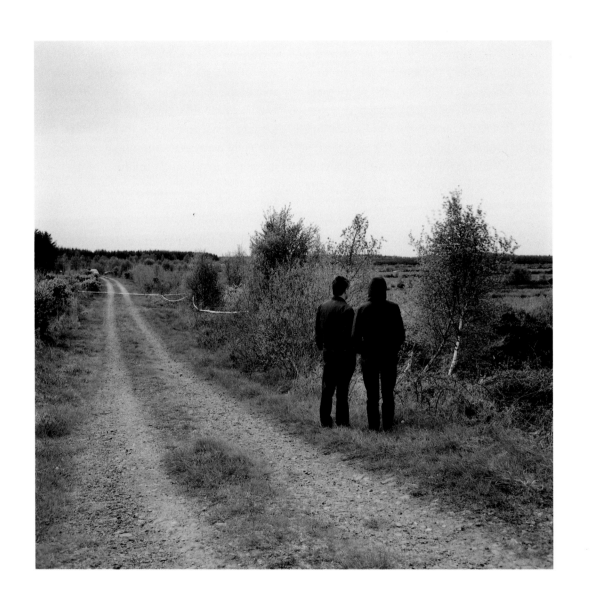

ACKNOWLEDGEMENTS

I would like to take this opportunity to thank a small group of people who have made a difference.

My parents and sister Kay, Jim and Lorraine for letting me do my own thing. The photographer Tony O'Shea whose photographs made me pick up a camera and whose interest and support helped me to 'continue the struggle'. Pino and Sandra for the Red Cross parcels and more. Sincere thanks to my agent Françoise Knabe (Berlin) and to Tanya Kiang at The Gallery of Photography, Dublin. Huge gratitude to Joe Murphy (Mercury Framing) Andre and Carol (GMS) for beautiful prints. My colleagues Daniel, Ian, Justin and Liza who make 'working' life a pleasure and a stimulant at my new home Dun Laoghaire Institute of Art, Design and Technology; also Tim Kovar who introduced me to the world of teaching. Merci to Bryan and Heather at the SBP, and scanmaster Pat Pidgeon who has tried to teach an old dog new tricks. Gracias to Mary and Bernard Loughlin for Molly and the opportunity to work out of Annaghmakerrig where this journey began. Likewise to Grainne Miller and to Michael Lawlor, book pusher extraordinaire. Thanks are also due to John Duncan and Richard West at Source Magazine while not forgetting Oliver Dowling and John Mulderrig.

Finally, a gigantic grazie to Gudók, artist of the floating world, we have survived by more than numbers and yes it is still beautiful; with a huge hug and many kisses to Molly, our hairy baby, and to Emer, Rex, Sid and Sad and all the puppies.

La lotta continua
David Farrell, May, 2001

European Publishers Award
for Photography 2001
eighth edition

Jury

Jean-Paul Capitani
Actes Sud

Dewi Lewis
Dewi Lewis Publishing

Günter Braus
Edition Braus

Andrés Gamboa
Lunwerg Editores

Mario Peliti
Peliti Associati

Dr. Ulrich Pohlmann
Münchner Stadtmuseum

Gero Furchheim
Leica Camera AG

with support from

Copyright © 2001

The Publishers

ACTES SUD (France)
DEWI LEWIS PUBLISHING (United Kingdom)
EDITION BRAUS (Germany)
LUNWERG EDITORES (Spain)
PELITI ASSOCIATI (Italy)

Photographs
David Farrell
Represented by Galerie Françoise Knabe, Berlin

Design
David Farrell

Production
EDITION BRAUS

Printed in Germany
Wachter GmbH

All maps are based on Ordnance Survey Ireland by permission of the
Government Permit No. 7325 © Government of Ireland

All Rights Reserved
ISBN 1-899235-88-4

The Photographs were taken
between July 1999 and September 2000